The Sketchbooks of REGINALD MARSH

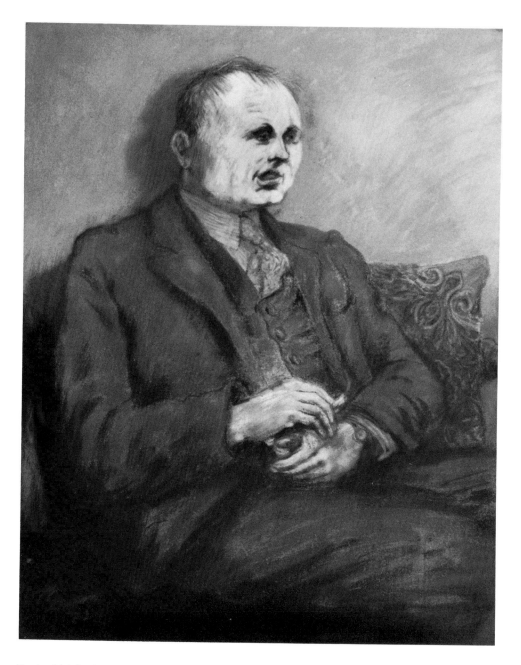

Reginald Marsh
Pastel by Peggy Bacon. Collection of Mrs. Reginald Marsh. About 1930.

EDWARD LANING

The Sketchbooks of
REGINALD MARSH

New York Graphic Society Ltd.

GREENWICH, CONNECTICUT

Designed by Peter Oldenburg
Printed by Murray Printing Company, Forge Village, Mass.

International Standard Book Number 0–8212–0538–2
Library of Congress Catalog Card Number 73–78793

For FELICIA

Through Mannahatta's streets I walking,
these things gathering . . .

—WALT WHITMAN, "Our Old Feuillage"

Acknowledgments

I wish to acknowledge my indebtedness to the many friends and associates who have helped me in the making of this book—above all to Felicia Meyer Marsh, who made the sketchbooks available to me and who graciously shared· with me many recollections of her husband. I also wish to thank Oliver Jensen, E. M. Halliday, and Mary Dawn Earley, editors of *American Heritage,* where the idea of this book originated in October 1972; Lloyd Goodrich, lifelong friend of Marsh and the author of a monumental book about him; John Clancy, director of the Frank K. M. Rehn Gallery, where Marsh's work has been exhibited for many years; Stewart Klonis, director of the Art Students League, where Marsh studied and taught; Mary Fife Laning and Lloyd Lozes Goff, who assisted Marsh with his murals in the New York Custom House; Gene Pyle, who accompanied Marsh on his sketching expeditions in order to photograph him, and Barbara Lyons of Harry N. Abrams, Publishers, for help in obtaining photographs of paintings.

E. L.

Contents

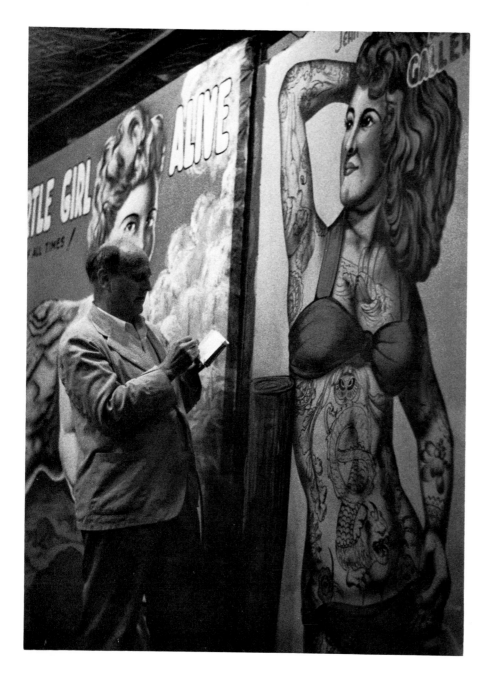

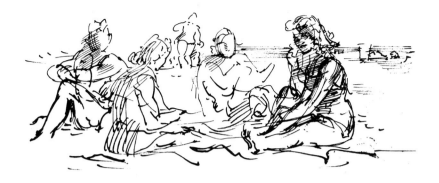

It is now nearly twenty years since Reginald Marsh died. Shortly after his death in 1954 an art magazine asked me to write something about him, and they published the piece as "homage from a colleague to the chronicler of New York life." Seventeen years later I wrote about him again, and this time it was called "a reminiscent tribute to a great American painter." Perhaps the turning point came in 1969, when the New York *Times* reviewed a Marsh exhibition under the remarkable headline, "Suddenly—An American Master." And now, in 1973, the same journal which twenty years ago patronized him as a "chronicler" refers to Marsh's New York as "The City That Never Was" and states that "Marsh was a Social Realist only briefly, at the start of his career; his use of tempera, and the old-master draftsmanship that his medium entailed, coincided with a raising of his sights to a level of the imaginative and fantastic quite unparalleled in American Art." The reviewers deal in catchwords and labels (they now label themselves "Art Historians," as undertakers call themselves "Morticians"). Marsh was never a "Social Realist"—but then neither was anybody else! Twenty years ago I wrote that the journals and the museums had come too late with too little. Today it is gratifying that "critical" opinion is a little nearer the truth (even if still pretty wide of the mark), just as it is heartening that in the marketplace his paintings fetch prices a hundred times higher than they did in his lifetime. However, I think none of this would have surprised him, or even interested him very much.

In 1955 I wrote, "In my opinion he was the greatest artist of his time," and an editor was incredulous. "Do you mean that?" he asked. "Greater than Picasso?" "Yes," I said. And today I am even surer of it! But it was easier for me to write about him then than it is now. I recently said so to a young artist, who asked me why. "Because the world has changed," I said.

But of course he couldn't understand that twenty years ago I felt I understood Marsh's world because it was my world, too. For me the wonderful excitement of his work lay in the subtle but intense transformations he wrought in the commonplace and all-too-familiar aspects of the ordinary world around us, both the outside world of the city we all lived in and the inner world of shared assumptions. I think T. S. Eliot had the same problem in mind when he wrote, shortly after the death of Virginia Woolf, "Her work will remain; something of her personality will be recorded; but how can her position in the life of her own time be understood by those to whom her time will be so remote that they will not even know how far they fail to understand it?"

Marsh ran a poor fourth after Benton, Curry, and Wood in Thomas Craven's stable of American Greats in the Thirties sweepstakes. In those days Craven was the bookmaker of American art, and like all gamblers he was laying odds on past performance—not the past of these artists but the American past itself. He found that past celebrated in Benton's Cowboys and Indians, Frankies and Johnnies. He found it in Curry's John Brown and Wood's Paul Revere. This was all very countrified, and Craven sometimes appointed Marsh his city slicker to round out his Boys' Picture Book. It was a sentimental view of America, and it was never Marsh's own view. He was in it but not of it.

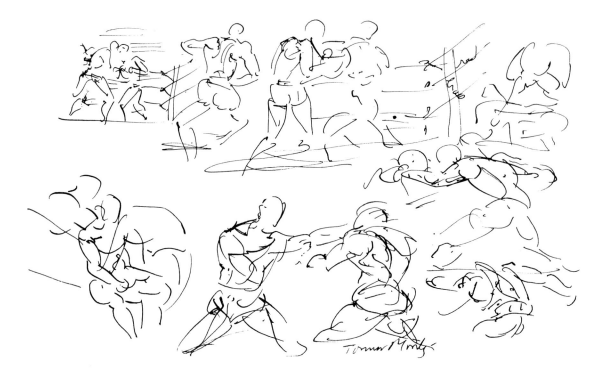

The venerable Thomas Hart Benton has recently said that he wishes he had lived in an earlier time, the "expansionist period" of America, the Nineteenth Century. That would be the time of Hamlin Garland, who said, "The more smiling aspects of life are the more American." Benton long ago withdrew to his native Missouri, but during his New York years he gathered around him in his class at the Art Students League several young Westerners who shared his expansionist enthusiasms. The most famous of these pupils, Jackson Pollock, remained in New York and undertook to expand himself. Years after Benton went back to Kansas City, Pollock would call his old teacher in the middle of the night and ask, "Tom, do you like my work?" and Benton would answer, "Look, Jack, you do your work and I'll do mine!" During several years of brilliant improvisation, Pollock turned Benton's theories of form organization into a series of abstract paintings. ("Jack always had a wonderful sense of color," Benton told us. "He couldn't draw, but he had a wonderful sense of color.") Then Pollock achieved the now familiar fulfillment of the Romantic-Expansionist: he drove his automobile at high speed into a tree.

I used to meet John Steuart Curry in Marsh's studio on Union Square. After Curry had gone, Reg would tell me, "John worries that he cannot sustain his reputation; he's afraid he's being passed by." Curry had had one very successful exhibition of paintings which were based on his Kansas boyhood. Later he was commissioned to paint a series of murals in the Kansas Statehouse at Topeka. These murals are a failed masterpiece. Curry quarreled with the legislators and abandoned the project unfinished. He retired to a position as Artist-in-Residence at the University of Wisconsin, where he died.

Grant Wood achieved some memorable pictorial images—"American Gothic," "Daughters of Revolution," and a few others—but his artistic production was meager.

I believe that what sustained Marsh and Benton was their basis in drawing. Both men worked as cartoonists in their youth and both sketched all their lives, Benton in the hinterland, Marsh in the city. Both were serious students of the traditions of their art, deeply absorbed in the work of the old masters. Benton, a mural painter, has chosen to carry on the tradition of "History Painting," a tradition going back to Poussin and Raphael and continuing into our own time. (Consider Benjamin West's "Death of Wolfe," David's "Napoleon Crossing the Alps," the murals of Delacroix— and Picasso's "Guernica.") Perhaps the difference between Benton and Marsh was that Marsh *did* live in an "expansionist period," for in his time America was fast becoming an urban civilization. Marsh lived and

worked on this frontier when it was as young and lusty and brawling as the Wild West ever was. When he painted his murals in the Custom House in New York in the Thirties, these enormous pictures of ocean liners and tugboats looked to us like enlarged documentaries, but soon after they were finished, the scenes which Marsh painted with such acute observation had become things of the past, and today they are history as well as art.

The Nineteen-Thirties, as we now can see with the clarity of hindsight, was one of the heroic periods of American art. It was a time, in art as in every other aspect of American life, of truly agonizing reappraisal. The country went broke. The empty bubble of the inflated Twenties had burst, and the Fitzgeralds and the Hemingways, the Bentons and the Currys, the Virgil Thomsons and the Malcolm Cowleys, the Diego Riveras, all came back from France because they had to; the money from home had run out. In Paris artists had been following the abstract styles then fashionable among the French. Back in the New World, they ran up their respective national flags. Their patriotism, however, was another abstraction. Marsh, too, visited Paris; in 1925–26 he spent six months there, but what he discovered was the Louvre. He spent his time copying Rubens and Delacroix and made up his mind to be an artist. Back in New York, he didn't need to search for his subject. It was all around him and he had been drawing it for years.

Throughout the Thirties artists sought some answer to the problems of the Depression, their own impoverishment and frustration and the wretchedness of their fellow men, and many of them fondly hoped to find it in the promises of the Russian Revolution. Political passions were high—and sometimes divisive and frequently hilarious. Benton for a time took an intellectual interest in Leftist political theories but became disaffected with the turmoil of New York and left the city. Marsh held aloof from every sort of politics. While others argued, he drew and painted. As I look back on it, it seems to me that every faction believed he belonged to them, and I guess he did!

Ultimately, the vague radicalism of the time, which served to give many artists a sense of direction and which provided them with social themes, was rudely shattered by an event which our Art Historians have chosen to overlook. Stalin signed the Hitler-Stalin pact and the revolutionary dream was over. What was left? Nothing but the early "abstract" exercises which Rivera and Benton had practiced in the halcyon Paris days. With nothing left to say, the disillusioned artists found themselves with nothing to do but to "push and pull on the picture surface," to use Hans Hofmann's

term for it. Pollock knew how to push and pull—Benton had taught him. (Benton called it "thrust and counter-thrust.") Art Historians pretend that this style was taught to the benighted Americans by refugees from Europe. What sensible commercial buyer would trade his trip to Paris for a visit to Kansas City? But by the early Thirties Reginald Marsh had already discovered that his life's passion was to draw and paint New York. He couldn't leave town. So to shut out the vain intellectual hubbub of the time he simply played dumb!

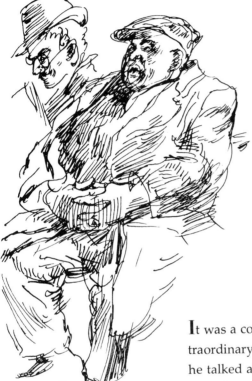

It was a constant pleasure to know Reginald Marsh. He was a man of extraordinary personal charm. Short and stocky, with red hair and freckles, he talked almost inaudibly out of the side of his mouth. The first time he visited my studio (this was in 1930 and we had just been introduced to each other by Kenneth Hayes Miller), he spoke disparagingly of the Woodstock artists who were very big names at the time, being favored by Juliana Force, the director of the Whitney Museum in its Eighth Street days. "They vegetate up there in the country and they never raise any hell!" he said, in the manner of a Dead End Kid. He left me with the disarming impression that I had been in the company of a tough little gangster. I soon learned that this manner was entirely defensive and that in reality he was a sweet, shy man of great sensibility and cultivation. He seemed somehow vulnerable, and all his friends wanted to protect him from harm. According to Aldous Huxley, Balzac said that art is a relation between the head and the heart, and Huxley added that with Balzac the distance between head and heart was a very short one, whereas in his own case the distance

was very great! Marsh was built like Balzac, barrel-chested and with no neck at all, and Marsh's *Comédie Humaine* is comparable to the Frenchman's for clarity and compassion.

It was a pleasure to know him and it was also a privilege. For an artist it was the sort of privilege a religious person would find in association with a saint. He was endlessly creative; he produced as Nature produces, turning out, with marvelous abundance, drawings and paintings, illustrations, etchings, engravings and murals; and all this work was accomplished with grace and apparent ease. He was inventive; the "Marsh Girl" was an archetypal figure, and many aspects of New York life became so intimately his own that it almost seemed he had thought them up—Coney Island, the Bowery, burlesque. He was dedicated; he was always working. After the day in his studio on Union Square was over, he walked the short distance to his apartment on Fifteenth Street and spent the evening at his etching press. And when the work in the studio faltered, he put a sketchbook in his pocket, picked up a couple of artist's fountain pens and set out on a sketching trip. He would walk along Fourteenth Street and take the Third Avenue El to Chatham Square and the Bowery. Or in warm weather he would go to the West Side wharves and sketch the kids who dived into the Hudson and the tugboats that puffed along offshore. In bad weather he would take refuge in the burlesque theater on Irving Place to sketch the performers and the audience. On fine summer days he would head for Coney Island.

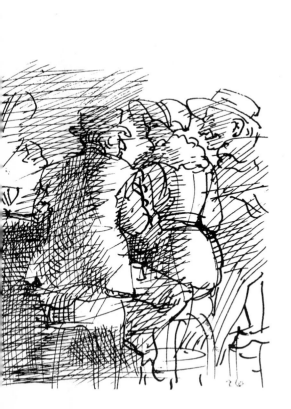

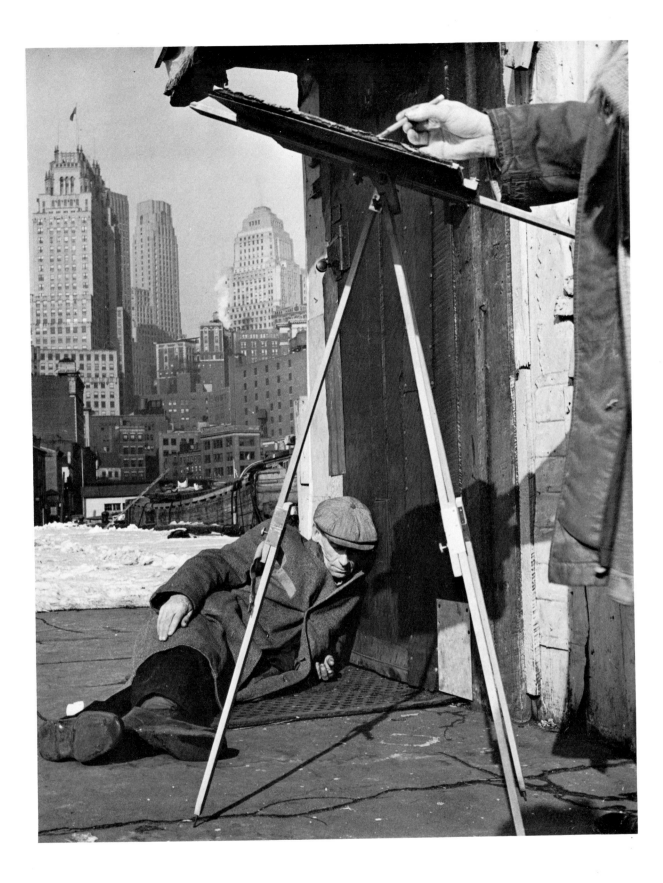

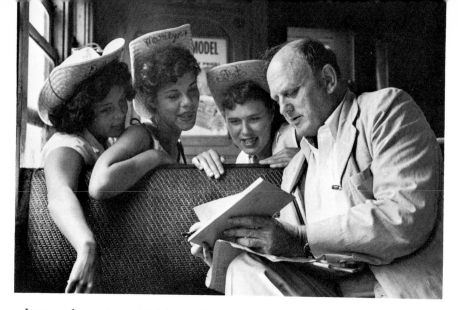

I remember going with him to Coney Island one day. When we got to the Boardwalk, he led the way to a bathhouse, where we changed into swim trunks. We picked our way over the massed bodies on the sand and went into the crowded surf. Marsh dog-paddled, his head held high above the water, while he ogled the churning arms and legs, bellies and bottoms. After that we dressed and went to "Steeplechase—The Funny Place." At the ticket booth we were waved inside without charge. (I later learned that George C. Tilyou had left orders that Marsh was always to be admitted free.) We watched the swings and rides and chutes while Marsh made some notes in his sketchbook. Back in Manhattan we went to Sloppy Louie's on South Street for dinner, and Louie picked up the tab (Marsh had drawn Louie's portrait sketch for *The New Yorker*'s profile of him). Then we walked up the Bowery to Strokey's Bar—and there our drinks were on the house. (A Marsh-style painting of the Bowery, featuring Strokey's, hung on the wall behind the bartender. When we left, Reg told me the painting was a forgery. "But I don't tell them that. They want to think I did it.") Finally we took the El uptown. We paid the full five-cent fare, though considering Marsh's celebrations of the El we should have traveled as guests of the railway.

His sketchbooks were the central fact of his career as an artist—I almost said of his life. He always used for his drawings and watercolors the best paper he could find. For his sketchbooks he carefully cut this paper to a size to fit his coat pocket. He shaped a couple of pieces of cardboard for covers, punched holes through papers and cardboard, and with metal rings made a sketchbook of fine rag paper. He had a supply of Waterman's artist's fountain pens that held India ink. I believe he never went anywhere without these sketchbooks and pens, and he drew almost incessantly.

At the time of his sudden death in Vermont in 1954, his wife, the artist Felicia Meyer, asked me to keep an eye on his studio, across the street from my own. It was a place I was very familiar with, since I had visited him there on countless occasions. I found it exactly as he had intended to return to it in a few days' time. (He hated the country!) It was in that orderly disorder that is typical of artists' studios. I entered it with sadness, knowing I would never find him there again. It was a small studio but one that exactly suited his needs. Situated on the top floor of an old commercial office building at the corner of Fourteenth Street and University Place, it commanded a view of Union Square. I went to the window and looked out, remembering how Reg used to pick up his binoculars and peer out over the view, catching glimpses of the crowded streets, the great equestrian statue of Washington at the entrance to the square, S. Klein's emporium beyond, and the Consolidated Edison tower looming over all. I remembered how his eye would catch sight of someone run over by an automobile or truck in the street below and we would watch while police cars and an ambulance hurried to the scene; then perhaps he would discover a group of nearly naked girls sunbathing on a roof across the square.

I turned back to the studio where in his absence his easel was strangely empty. I looked up at the wall nearby and was reassured to find there that little painting which he kept as a sort of mascot—one of his girls. She had been there for years, changing constantly but ever the same, a talisman, pert and bouncy. She was one of the touchstones of his life. Every evening

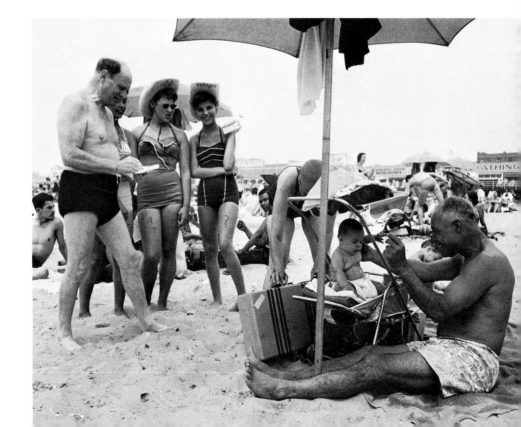

when it was time to go home he looked up to this little painting and brought her down to the easel for a few minutes while he reworked her with the last remaining pigments on his palette. I wonder where she is now. When I last saw her she was many inches thick!

This little studio contained his workroom (the easel occupied most of it). First, an entrance area with chests of drawers and filing cabinets. From this a narrow stairway led to the small gallery on the roof that he used mainly for the storage of paintings, hundreds of paintings in cabinets behind wooden doors. These doors were plastered with the black-bordered death notices which the National Academy of Design sends out to its members.

Returning to the filing cabinets below, I looked into them. One big architect's file contained his wash drawings on "elephant" and "double-elephant" Whatman papers. One after another I held in my hands big drawings of all his favorite subjects, almost always with another great drawing "verso." Then I turned to the cabinets where his pocket sketchbooks were filed and began to look through them.

I discovered that he had filed this series of sketchbooks in strict chronological order over the years, beginning in the early Twenties and continuing until his death. I had thought I knew them well, but I realized I had taken them for granted and that, much as I had always admired them, they were far richer than I had supposed. I had thought I knew *him*, but here I found him as he had known himself. I spent the following days poring over these sketchbooks, beginning with the early pencil drawings and watching the development of the pen-and-ink line that became his supreme medium. I sat with him in the sidewalk cafés of Paris, met Mahonri Young and Llewelyn Powys and John Rothenstein, went to the Folies-Bergère and the Cirque d'Hiver, and strolled along the Seine. I returned with him to New York and the beginnings of his favorite subjects, the burlesque and the speakeasies of the late Twenties. In these pages I met his friends and acquaintances, went with him to the theater and to parties (he said to me one day, "I don't much like parties. I'm never happy unless I'm the center of attention. When I feel neglected, I reach for my sketchbook and soon everybody is gathered around, watching me draw!"), sat beside him in the subway and the El and the Staten Island ferry, walked along Fourteenth Street and the Bowery, explored the railroad yards and the waterfront. It was a pictorial diary such as no other artist, I believe, has left behind him, at least not over so long a period of time.

Marsh was a zealous guardian of his talent, as the careful filing of his sketches and drawings showed. He seemed to regard his work as a testament which he was charged to complete. In his later years he developed a

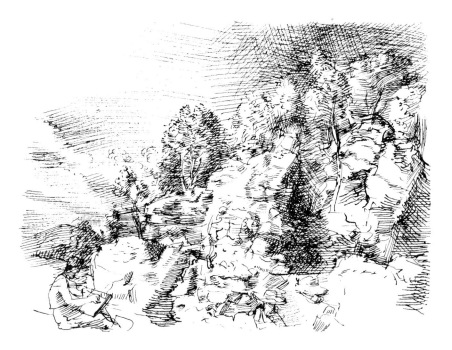

fear of airplanes which sometimes made travel difficult. Ultimately this phobia extended to automobiles and he was in trouble. It was my belief that he felt he had important work to do and that he had no right to take chances. Curiously, he had no fear of ships or trains, but then he had drawn and painted these with loving care for a long time and had learned to trust them.

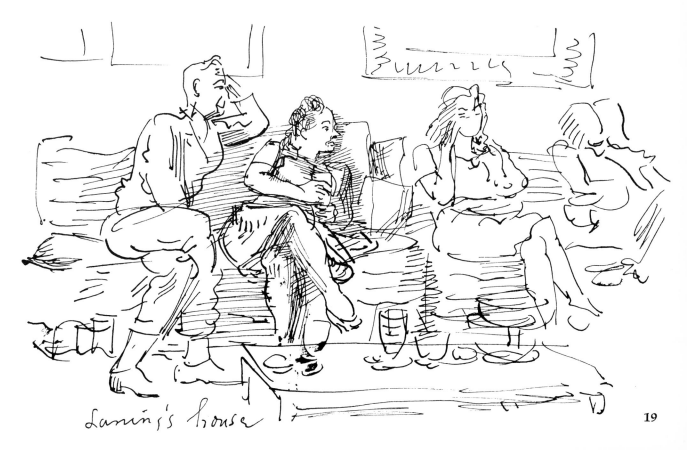

Laning's house

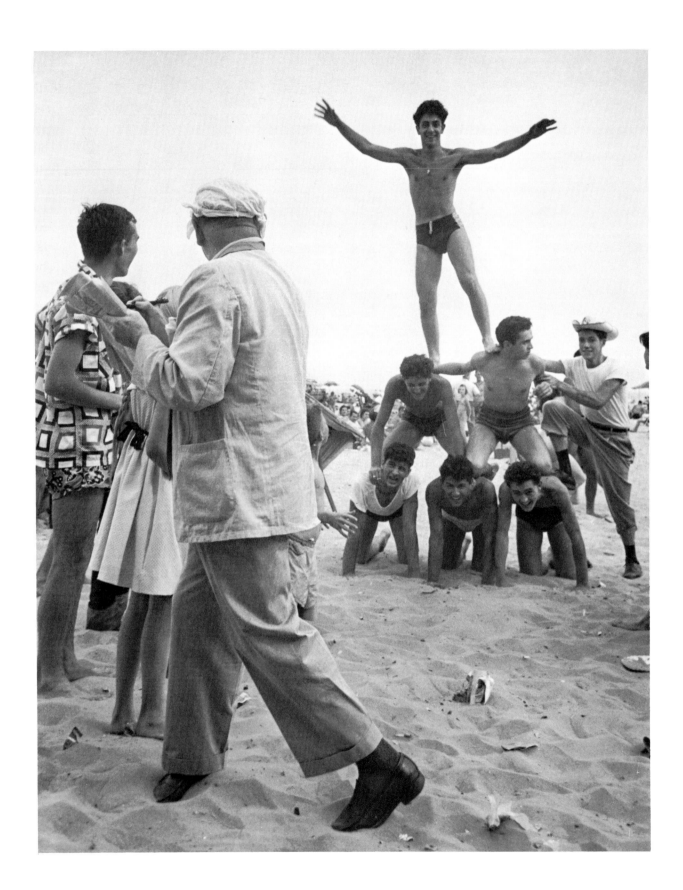

He knew that his draftsmanship was unsurpassed. He was even vain about it. He had a devastating term for less accomplished draftsmen—"the dead hand." His painting was the ultimate extension of his superlative draftsmanship. He was primarily a tempera painter, even a watercolor painter (he handled tempera like watercolor). The fullest development of oil painting, its range of opacity and transparency, always eluded him. "Whenever I get into opaque pigment, the painting dies!" he said to me. He had seen the miracle of such masterly painting as that of Rubens and he doggedly aspired to it. In the last years of his life, still struggling, he submitted himself to the tutelage of Jacques Maroger, a French academic painter who had interesting ideas about the mediums of the old masters. It was embarrassing to visit him when Maroger was there and to hear Maroger scold, "No, not like that, like *this!*" (Marsh could paint rings around Maroger!) This unfortunate and futile enterprise pained Kenneth Hayes Miller, who believed, quite rightly, that Marsh *had* his medium, the one which was right for him. Like all the American Boys, Marsh was overreaching himself. Like Fitzgerald, Pollock and Hemingway, he killed himself—or something in our culture goaded him, and them, beyond human endurance, and *we* killed them. Miller always told us, "Know your limitations," but this is the lesson the American Boy, even the most studious, never learns (perhaps because it's un-American). Reg had to be Champ.

One night, it must have been around 1933, I went to dinner with Reg and Jacob Burck (then the cartoonist for the *Daily Worker)*. We talked about the newspaper cartoons of Boardman Robinson, whom we admired, and Reg suggested we go back to his apartment and look at his scrapbooks of Robinson's work. (I remember that as we looked at these things we all felt a sense of disappointment. Reg muttered, "The dead hand.") Reg was then living alone, between marriages. In his top floor apartment on Twelfth Street he had installed his etching press. When we entered, he looked at the press and said to us, "John Curry was here this afternoon. He put his shoulder under that press and lifted it off the floor!" Reg took off his jacket and lunged at the press. He strained until the sweat poured from his forehead. He couldn't budge it. Some years later, on a government art assignment during the Second World War, his ship crossed the Equator and he was "hazed." He was blindfolded and required to "walk the plank." Reg didn't merely jump, as he was commanded to do. Instead he posed on the board and dived into the empty canvas tank—and broke his arm. At the age of fifty-six he died of a heart attack, another victim of the Hemingway syndrome.

Marsh was born in Paris in 1898 in an apartment above the Café du Dôme. His parents were both artists, his father a successful mural painter and his mother a miniaturist. There was plenty of money (Grandfather Marsh had been a rich Chicago packer), and Alice Randall and Fred Dana Marsh were living the life of genteel expatriates. Back in America, Reginald grew up in Nutley, New Jersey, and New Rochelle, New York. He attended Lawrenceville School and Yale. This background was quintessential New York, but upper class New York, not the New York of the slums and the ghettos. Of another Yale man, Cole Porter, a biographer has written, "Like any Keys man, he had a certain curiosity about the gutter," and so did Marsh. He once told me that when he was a boy leading a sheltered life in a big house in New Jersey, he used to stand in the windows, looking down the long slope of the lawn toward the distant railroad line. There at the bottom of the yard on summer days hoboes would be sprawled out on the grass. Reg would look out from his windows at these tramps, wondering what sort of men they were and what lives they led. I think he went on wondering all his life.

At Yale, Marsh drew for the *Yale Record.* Lloyd Goodrich, a friend of Marsh from the days of their boyhood in New Jersey, says that the Marsh Girl made the *Yale Record* the most successful college journal in America. Its editor, William Benton, later Undersecretary of State and United States Senator from Connecticut, made Reg the art editor in 1920, during Marsh's senior year. Benton remained Marsh's friend and patron to the end of his life. (When I was a Fulbright Fellow in Italy in 1950, Senator Benton came to Rome on a speaking tour and the Embassy encouraged the American colony to turn out for the occasion. As the Senator made an impressive entrance into the reception at the Palazzo Venezia and paused to look about, I said to him, "Senator, we have a mutual friend, Reginald Marsh." Suddenly all his armor was put aside; he relaxed and said to me, "Ah, Reg—I *love* Reg!")

After graduation from Yale, Marsh came to New York and began to draw for newspapers and magazines. The new tabloid paper, the *Daily News,*

paid him a thousand dollars a month, and from 1922 to 1925 he had a column of sketches in that paper in which he depicted vaudeville and theater acts and nightclub turns and gave each performance a percentage rating. When *The New Yorker* was started in 1925, Marsh began drawing for it in its second issue and was actively connected with the magazine through 1931. One day during this period Frank Crowninshield asked him if he would go out to Coney Island and make a page of sketches for *Vanity Fair*. Marsh later told me this was the first time he ever visited the place. Throughout his career he did many illustrations for other periodicals, including *Life, Fortune,* and *Esquire,* and for many books, such as Defoe's *Moll Flanders,* Dreiser's *Sister Carrie,* and Dos Passos' *U.S.A.* He designed theater curtains for John Murray Anderson's "Greenwich Village Follies" and collaborated with Robert Edmond Jones on sets for "Fashion, or Life in New York."

In his work for the *Daily News,* Marsh was influenced by Edmund Duffy, whose cartoons for the Baltimore *Sun* he greatly admired. All his life he studied the drawings of the great English illustrators: Gillray, Cruikshank, Leech and Tenniel. This background in illustration resembled that of John Sloan and other members of "The Eight," the so-called Ashcan School, many of whom began their careers as illustrators in Philadelphia, and it was in the American tradition. Winslow Homer, for example, was an illustrator for *Harper's Weekly,* an "artist-correspondent" during the Civil War, before he ever began to paint.

Marsh's concern with illustration involved him in the whole tradition of Western art. He knew that Giotto and Michelangelo had illustrated the

Bible, that the artists of the Renaissance had taken their themes from Ovid, that Delacroix had derived his from Shakespeare. Marsh *had* his theme; it arose from a deep inner compulsion. His problem was how to delineate it. Concern with story and illustration became unfashionable in his time. He didn't care. He was intelligent, but he was never "intellectual." He lived by his art, and his art had roots which reached back to a period earlier than universal compulsory education, to a time when the metaphor of art had to be acted out, not merely verbalized. This always meant a degree of vulgarity in his work, and it was a saving vulgarity. While many of his contemporaries sought refuge in "non-literary" and "abstract" styles, Marsh remained content to be entertaining. (Maybe "a talent to amuse," as Noel Coward called it, is rarer and more important than we have thought.) It is ironic that Marsh, who was willing humbly to illustrate words and tell stories, ultimately transcended the word and created a logos, while the abstract painters, eschewing literature, ended as illustrators of the verbalizations of critics like Clement Greenberg and Harold Rosenberg (as Mr. Rosenberg has been the first to admit). And because these critical exercises were by their nature unillustratable, the abstract canvas ultimately became blank.

Tradition was easy for Marsh to come by. Not only were his parents both painters; his first wife was a sculptor and the daughter of artists (her father was Curator of Painting at the Metropolitan Museum). His second wife, herself a painter, was the daughter of painters. A recent biographical account correctly states: "He lived in New York, spending weekends in Dorset, Vermont, almost every summer, and winter vacations visiting his father at Ormond Beach, Florida, where he painted watercolors." But the tradition Marsh embraced was not the genteel tradition!

It is easy to say of any great artist that he did it all himself, and in America we are taught that this *must* be so. No less an authority than W. H. Auden has told us that in Europe it has been customary for art to proceed by schools and movements, while in America discipleship is unthinkable. But Auden was paying lip-service to American prejudice. Marsh's achievement was his own, of course, but he readily acknowledged what he owed to others. He was the most independent of men, but he was also the most persistent student. He never stopped studying, never regarded his knowledge as adequate, never ceased to *wonder*. I remember going to his studio one day and being introduced by him to a stranger. They were poring over bits of calligraphy—and dollar bills! Reg had found the man on Fourteenth Street selling examples of penmanship (for a quarter he would write the purchaser's name in fine italic script on a card). Reg had watched for a

while and then said to him, "Where did you learn to use your pen like that?" The man replied, "I used to be an engraver at the Bureau of Printing and Engraving in Washington." Reg invited him to come up to his studio and immediately began to pay him for lessons in engraving.

His periods of study at the Art Students League were inevitable. (Where else, now or then, could an artist study?) But while brief periods with Sloan or George Luks were no more than extensions of his own predilections, his study with Kenneth Hayes Miller was critical. I am sure that it was partly his genteel relatives who impelled Marsh toward Miller's class at the League. But it was also much more. Miller was the Academy of his time, and not to have submitted oneself to Miller's examination was not to have gone through the mill. And Miller was of inestimable value to Marsh. He resolved at a glance the problem of gentility. He looked at Reg's early, awkward burlesque sketches and at his more conventional landscape watercolors and said, "These awkward things are your work. These are real. Stick to these things and don't let anyone dissuade you!" In 1944 Marsh wrote, "I still show him every picture I paint. I am a Miller student."

Renoir said, "The only thing worthwhile for a painter is to study the museums," and William Benton once reported that Marsh told him he had copied every great painting in Europe. In the sketchbooks there are scores of drawings after the great works of the Renaissance and baroque masters: Titian, Tintoretto, Veronese, Rubens, Delacroix. On one of his tours of the European galleries he met Thomas Hart Benton, another great student of the baroque masters and a man who was as fluent with words as Marsh was tongue-tied. From Venice Reg wrote a postcard to Stewart Klonis: "Yesterday we ran into Tom and Rita Benton and today Tom and I went to

Dante et Virgile conduits par Phlégias, traversant le lac qui entoure la ville infernale de Dité

the Scuola San Rocco. I never realized till now how much Tintoretto owed to Tom Benton!"

When an admirer said to Delacroix, "Master, you are the Victor Hugo of painting," Delacroix replied, "You don't know what you're talking about. I am a classicist, pure and simple." Marsh would have said the same thing. Believing that the proper study of mankind is man, he decided that he needed to know more about anatomy. He arranged to take lessons at New York Hospital in the Cornell Medical School. This involved the dissection of cadavers. I asked him if he learned anything from this. "No," he said, "nothing at all. The only way an artist can study the subject is in the best anatomical plates in the best books. I asked them at the hospital who, in New York, knows more about anatomy than anybody else and they said it's old Doctor So-and-So but he retired years ago. I asked where I could find him and they said, 'Well, he spends every day in the Library.' I went there and I found him and I said, 'What are the best anatomical plates and diagrams, the best anatomical books?' The old man said, 'Vesalius.' "

Marsh began to draw from these earliest of all anatomical plates and from the drawings of masters like Raphael, Leonardo, and Michelangelo, and to relate these to each other. Around this time I acquired a whole skeleton from the Cooper Union, where my wife was a supervisor in the Museum. It was nothing but a disassembled bag of bones. I told Reg about it and said I didn't think I would ever do anything with this treasure. He came at once to my studio (then in Bleecker Street), threw the gunny sack over his shoulder, and started off to Fourteenth Street, half a mile away. Until he called to tell us he was safely home we held our breath. What if he had met with an accident and the bones had been scattered over the street?

Marsh's sketching was never a mindless copying of light and shade but a penetrating examination into the structure and form of figures and objects. One day in the early years of the Second World War he took the Staten Island ferry and was soon busy drawing the ships in the crowded harbor. Suddenly two men appeared and sat down, one at either side of him. "What do you think you're doing?" they said. "Come with us." They took his sketchbook from him, and at Staten Island they transferred to the ferry to Brooklyn, where they made their way to FBI headquarters. At the entrance they told him to wait on a bench and they took his sketchbook to an inner office. While he waited he reached into his pocket for a spare sketchbook and began to draw from memory the ships he had seen in the harbor. Finally the agents returned. They looked at what he was doing. His sketches from memory were as vivid and detailed as the origi-

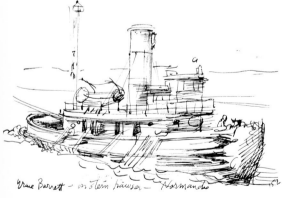

Irene Barrett — on stern hawser — Normandie

nal drawings. "Oh, go away!" the FBI men said to him. "There's nothing we can do with you!"

Studying his sketchbooks, one finds that certain subjects preoccupied Marsh all his life. The hoboes lying in the sun near the railroads become the derelicts he saw sleeping under the bridges of Paris, and these are transformed into the bums of the Bowery. Finally all the world's a stage, the burlesque stage. The clowns of the circus and the comedians of the burlesque are the prototypes of all his men; the showgirl and the striptease artist are all his women. When Mayor La Guardia, in an access of propriety, chased burlesque out of town, Marsh followed it to New Jersey. Stewart Klonis recalls how Marsh came in to the Art Students League, where he was teaching a class in drawing, and told Klonis he had just returned from Union City and the burlesque show there. "Since La Guardia closed them down here, they are scared over there, too," he said. "They won't allow cameras; they won't even permit sketching. But I got around that," and he took a tiny sketchbook, no more than three by four inches, from his pocket and showed it to Klonis. "I drew *inside* my pocket," he said. "These won't mean much to you, but they mean something to me." Rose la Rose, reproduced on page 82, is from this sketchbook.

When I think of the importance to Marsh of the burlesque, I recall an act I saw at the old Haymarket on the West Side of Chicago in the early Twenties. Before a backdrop depicting a city street, two disreputable characters are exchanging obscenities when suddenly a pretty girl walks on from the wings and minces across, looking out at the audience, and exits on the other side. This apparition throws the drunken bums into great disorder. The girl reappears and crosses again. This time the effect is almost

disastrous. With her third passage they are reduced to complete helplessness. This same girl walks down Marsh's Bowery.

D. H. Lawrence wrote, in *Classical American Literature*, "The old American artists were hopeless liars. But they were artists, in spite of themselves. Truly art is a sort of subterfuge. The artist usually sets out—or used to—to point a moral and adorn a tale. The tale, however, points the other way, as a rule. Two blankly opposing morals, the artist's and the tale's. Never trust the artist. Trust the tale. The proper function of a critic is to save the tale from the artist who created it." Can we save the work of the artists of the Thirties from the artists themselves? Can we save it from the Art Historians, who are always deceived by the artists' lies? I think Max Eastman was acting like a genuine critic when he told Ernest Hemingway, in Maxwell Perkins's office, "Ernest, take the false hair off your chest!" Can we save the murals of Thomas Hart Benton from Tom's old vaudeville turn as a cracker-barrel philosopher? Perhaps we can if we examine the manner in which Thomas Craven, himself a failed painter, was taken in by Tom's act—and then proceed to look at the murals themselves. I suggest that we'll find that their whole content lies in their jazz rhythm, that this is their message, and that their subject matter, their horse-opera scenarios, are as negligible as the lyrics of "Tiger Rag" and "Jazz Me Blues." The "moral" which all these artists point is the dominant moral of their time and place: the puffed-up preponderance of American energy and "rugged individualism," the cult of *machismo*. (Can this perhaps be the real meaning of Gertrude Stein's famous observation, "You are all a lost generation"?)

What is absent from this moral is love. When the Great Gatsby and his friend are talking about the tinkling music of Daisy's voice, Gatsby says, "Yes, it's the sound of money." And jazz is the music of the whorehouse. Marsh's omnipresent girl strides through his work in a Triumph of Death, a *dea ex machina* in a world of men without women. She is not real, but merely a projection of Marsh's fantasy. If Marsh is Ishmael, she is the Great White Whale.

William Benton wrote, "One of Reg's paintings I bought largely for the title. This is a picture of a couple going through the Tunnel of Love at Coney Island. The man looks pop-eyed and scared by the terrifying dragons and ogres. An old guard in a grey uniform dozes. The girl, a satiated blonde, looks as bored as the guard. She looks as if she's been through the love tunnel a bit too often. The title of the picture when I bought it was 'The Sorrow and Futility of Man before the Beauty of Woman'. . . . After a few months, Reg came to me and wanted to borrow the picture

montandon Pa

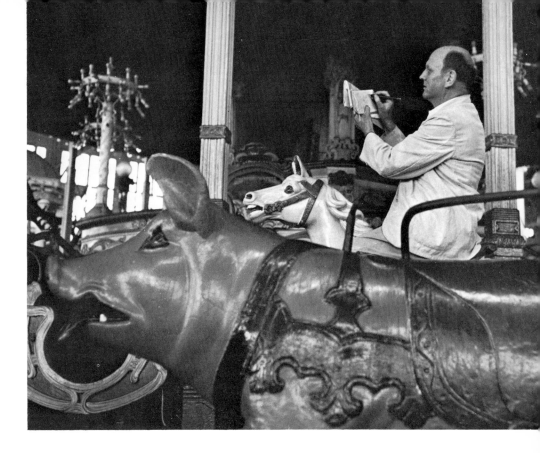

to send to the Carnegie Exhibit in Pittsburgh. He changed the title, and called it 'Eldorado.' I told Reg that he couldn't change the title—that I had bought the original title. He insisted. We never got this one settled."

If burlesque provided Marsh with his basic form and pattern, he was following an old and fruitful tradition. Watteau had taken the *commedia dell'arte* as his pattern in much the same way that Marsh followed burlesque, and if Watteau's picture is elegant and gracious and Marsh's is vulgar and tawdry, it is the world that has changed. Artistically, Marsh was as refined as Watteau. He drew as well; his adjustment of means to ends was as subtle and perfect; his scope was greater. John Lahr, in his biography of his father, who had been a burlesque comedian in his early days, has written that "the clown profanes the world in order to define the sacred." I believe Marsh's work tells us more about the Decline and Fall of the American Empire than that of any other artist in any medium.

Only Edward Hopper was as minatory. I recall a big gallery of Hopper's work at the Biennale in Venice twenty years ago. (I had the place to myself. I believe Hopper's work is meaningless to Europeans.) As I went from one painting to another, I became more and more uneasy. I left the gallery and sought fresh air outside. Then I went back to try to discover what made the work so disturbing. There was of course the awful lower-middle-class boredom, the lifeless edge-of-town pall, the familiar Edward Hopper

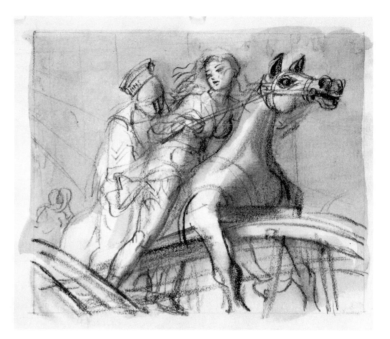

environment. But then I discovered something I hadn't noticed in Hopper's work when I had seen his rather rare paintings one at a time. In nearly every picture there was a black hole, a bottomless pit. It was the darkness where the highway disappears into the trees or the railroad track enters the tunnel, and it was as if all the air in the gallery were being sucked out through these vents. Hopper's America is a place of death.

I think Marsh's quality is more profoundly unsettling than Hopper's just because Marsh was so much more abundant. When one looks at a painting by Hopper, one wonders, "Where *is* everybody?" And then with Marsh one finds, "They're all *here!*" ("But little do men perceive what solitude is, and how far it extendeth. A crowd is not company, and faces are but a gallery of pictures, and talk but a tinkling cymbal, where there is no love.")

Marsh worked very hard and he accomplished his mission. With the advantage of hindsight, I now think I might have realized that he was nearly done. He said to me one day, "I'm beginning to repeat myself." On one of my last visits to him I found him at work on a familiar subject, the Coney Island Steeplechase. A British sailor and a girl are astride the wooden horse that races along a rail. The girl is blithe and smiling, as usual, but the sailor has died and the horse is like the horses in a medieval Apocalypse. Its eyes are rolling, and its nostrils are distended. "I can't finish it," Marsh said. "It's dead and I'm going to throw it away." He had taken a grey pigment and painted out the background, leaving sailor, girl, and

horse isolated. "Don't throw it away," I said. "Give it to me." He handed it to me as if he were glad to be rid of it. I think that with this painting he demolished the form which had sustained him. A change of title wouldn't serve now. *La commedia è finita.*

He said to me, "Everything I've loved is disappearing. They've torn down the El; the burlesque is gone; I hardly recognize Coney Island any more." And when, shortly before his death, the American Academy of Arts and Letters awarded him its gold medal, he got drunk before the ceremony and became even more tongue-tied than usual. He said to this self-important assembly, "I am not a man of this century," which surely seemed preposterous. But I think that, in the sense that he transcended his century, he was deeply right. In the lonely crowd of his paintings and drawings, Marsh still says, for all of us, "I'm a stranger here myself."

Steeplechase.
Collection of Edward Laning. 1954.

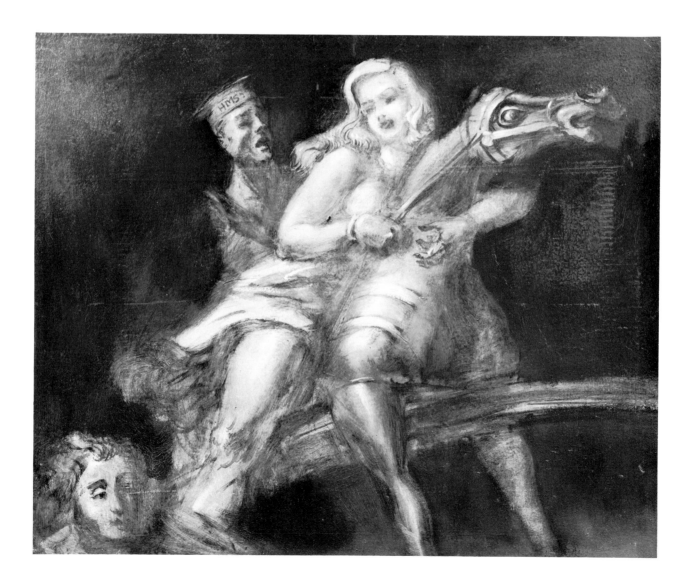

*All the color sketches and nearly all the black and
white sketches are reproduced in their actual size.*

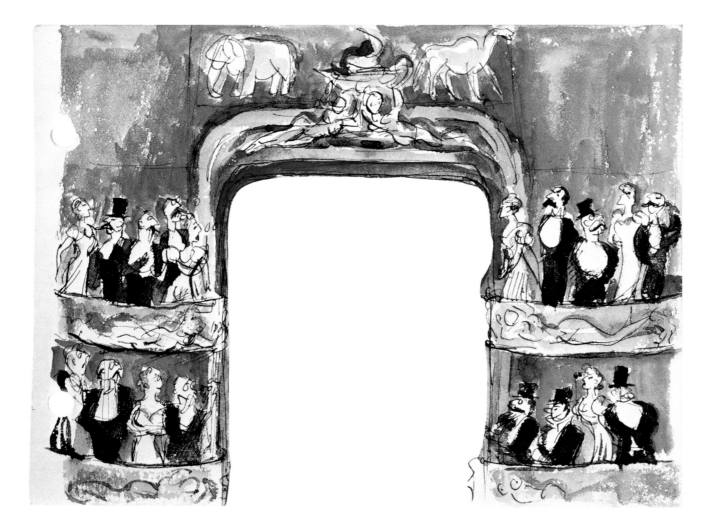

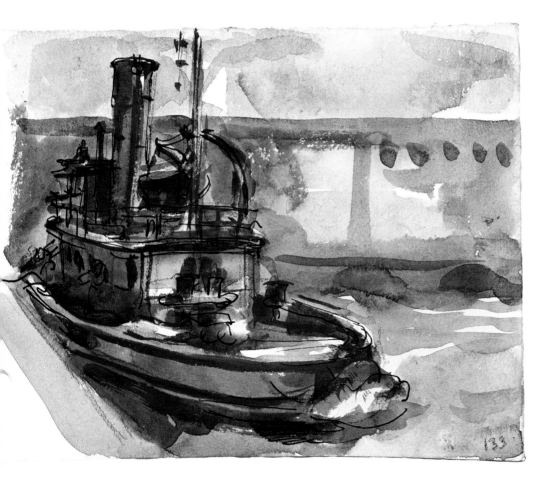

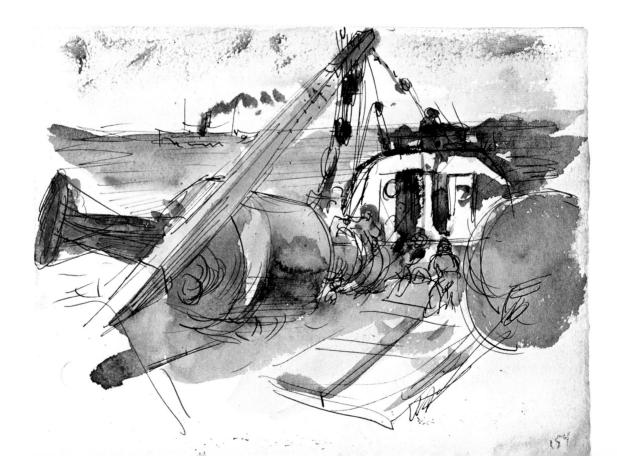

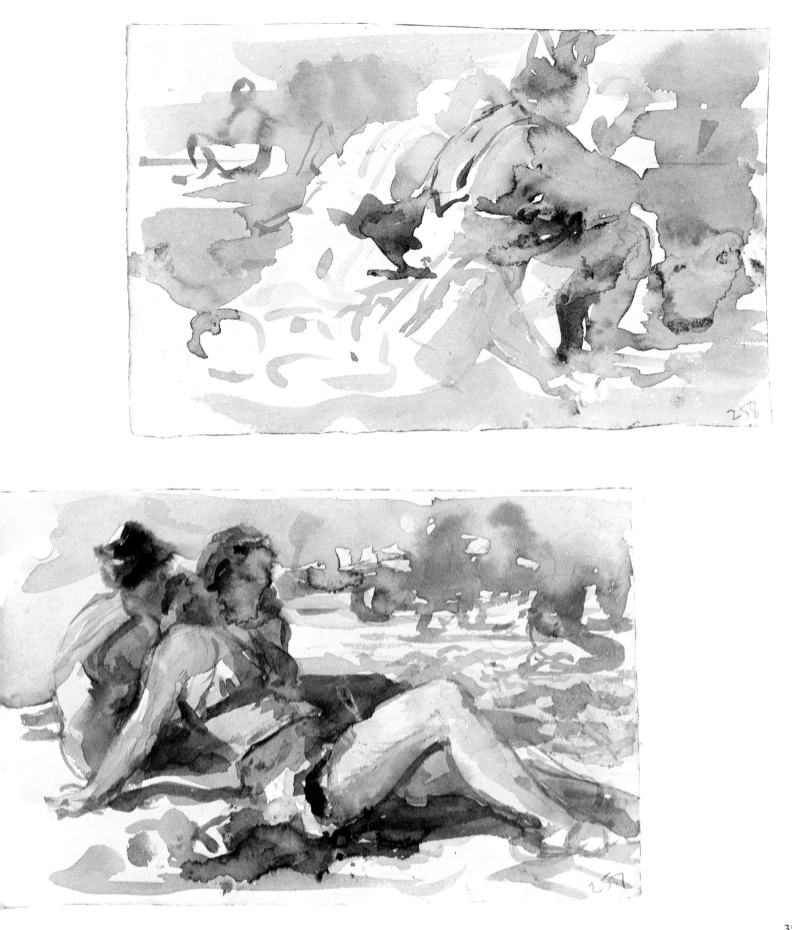

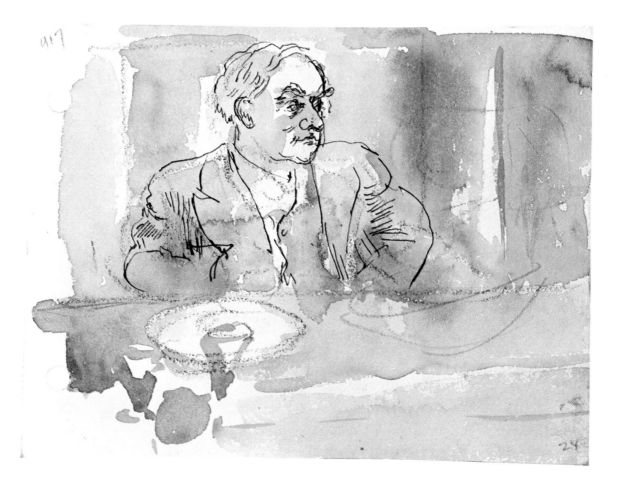

Versailles

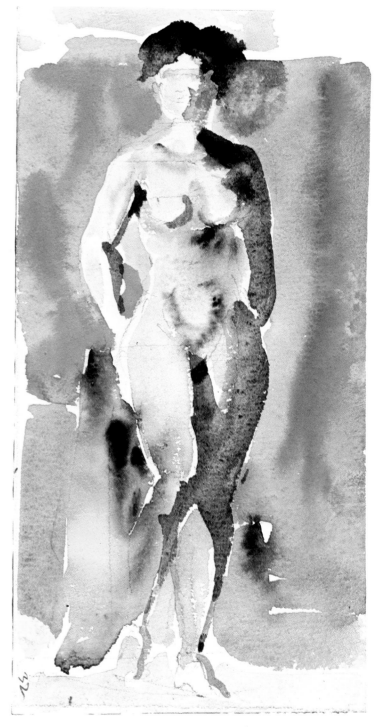

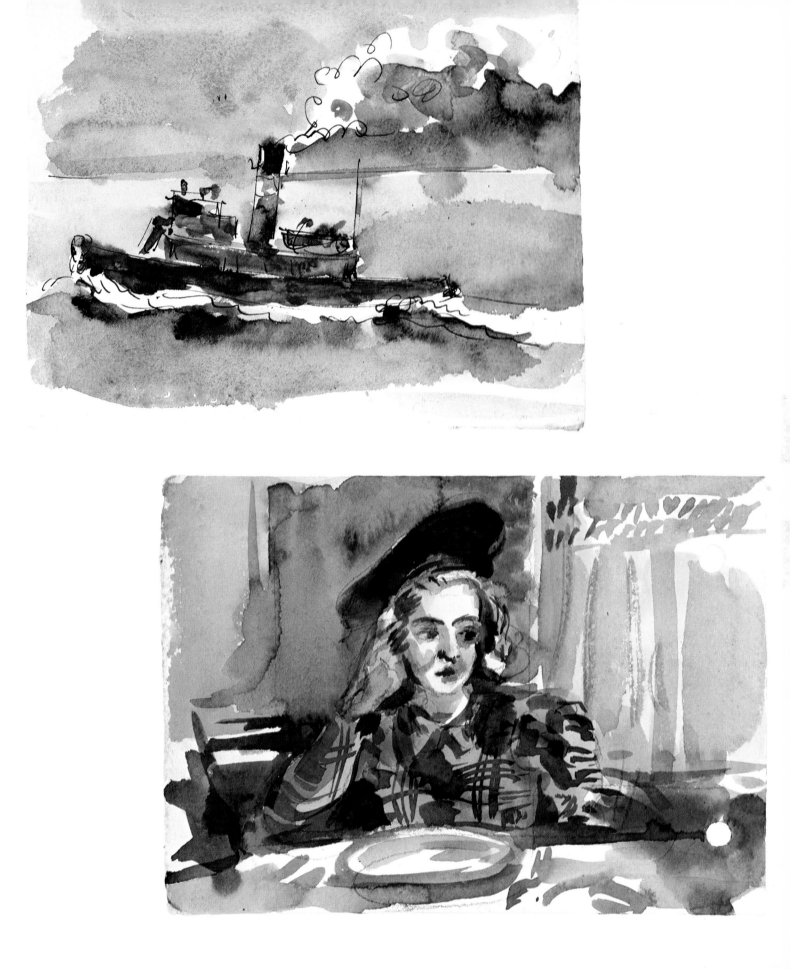

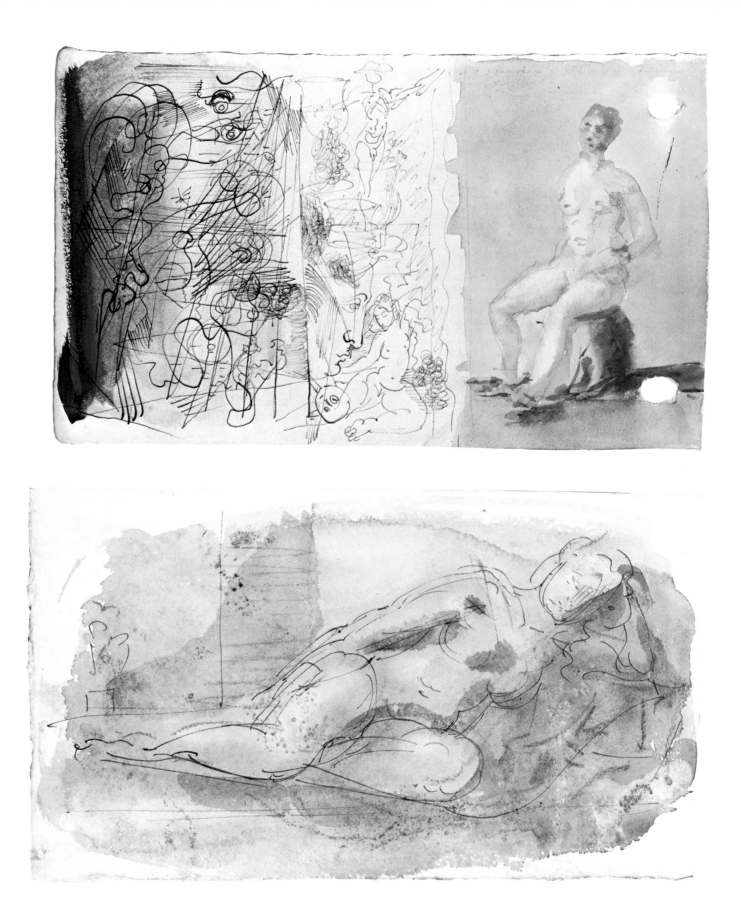

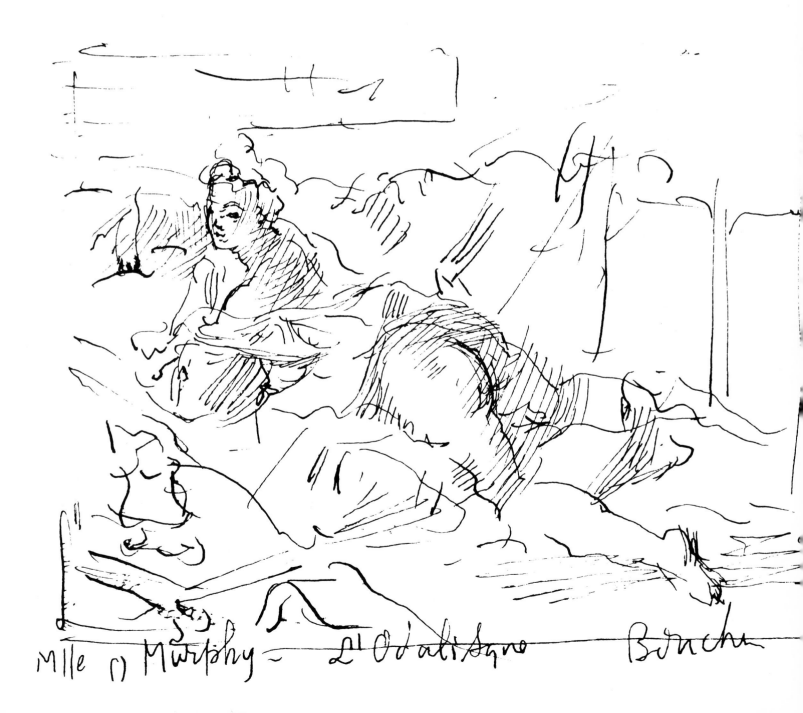

Mlle O Murphy — L'Odalisque Boucher

Marsh's six-month sojourn in Paris in 1925–26 produced many of the first sketches he made in the pocket sketchbooks which he subsequently carried with him everywhere. In these Paris sketches one finds many of his enduring themes already established. The derelicts "sous le Pont-Neuf" became his Bowery bums. At the Folies Bergère and the Cirque Médrano he found the prototypes of the strip-tease and the comics of burlesque. The cafés of Paris became the "speakeasies" and bars of New York.

During these months in Paris, Marsh copied many paintings by the great baroque masters, especially Rubens. Aldous Huxley has written, "The baroque style in the plastic arts is essentially a comic grand style," and it was upon the baroque masters that Marsh based his own Human Comedy.

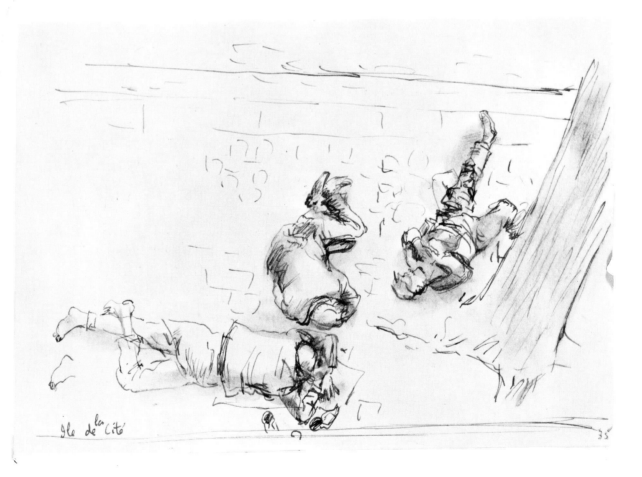

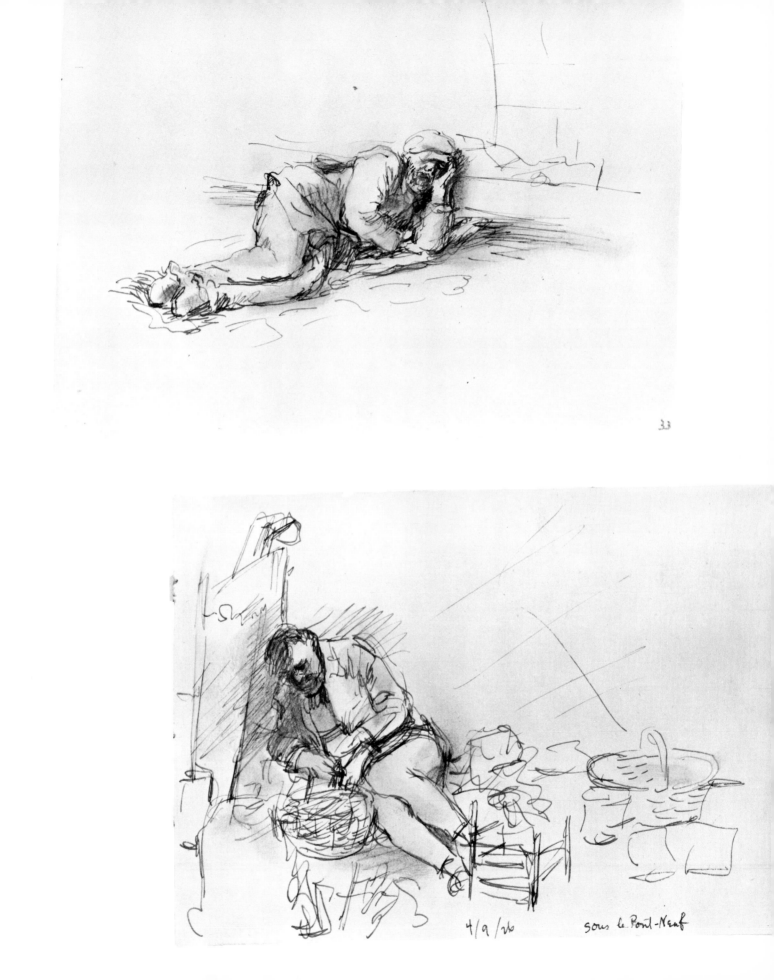

33

4/9/26 sous le Pont-Neuf

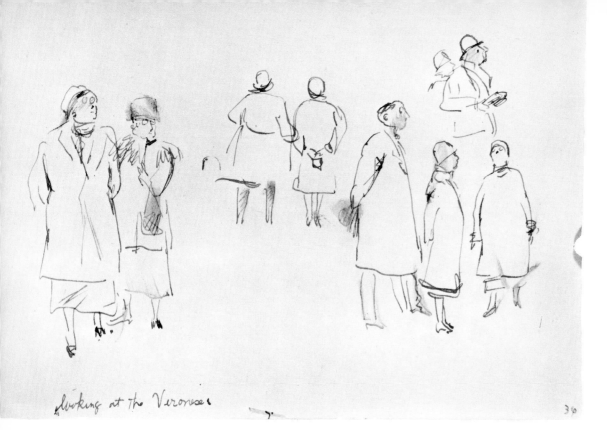

looking at the Veroneses

Tout Paris
—from the Louvre

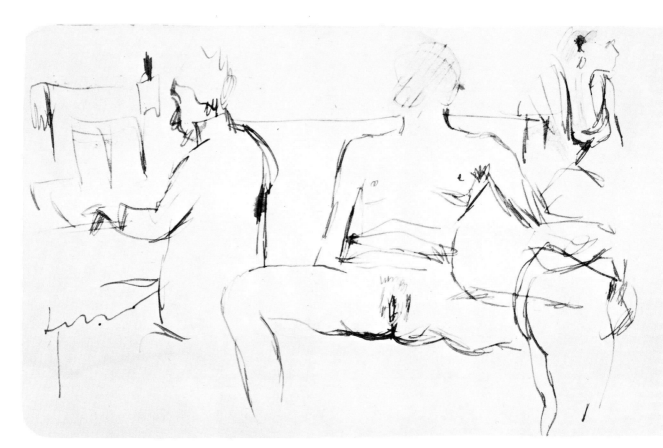

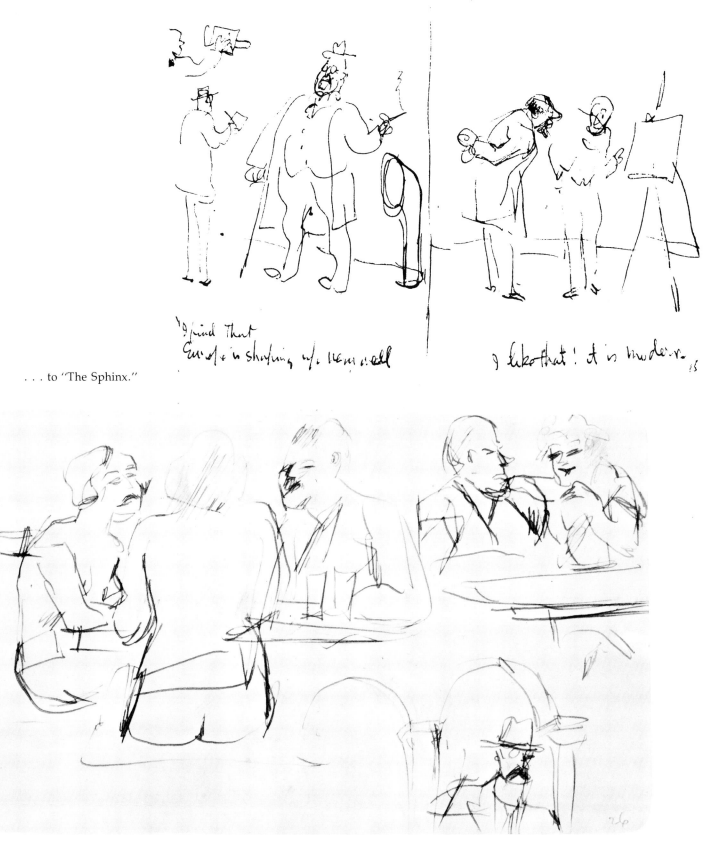

"I find that
Euroful is shaking up Kempbell

I like that! it is modern.

. . . to "The Sphinx."

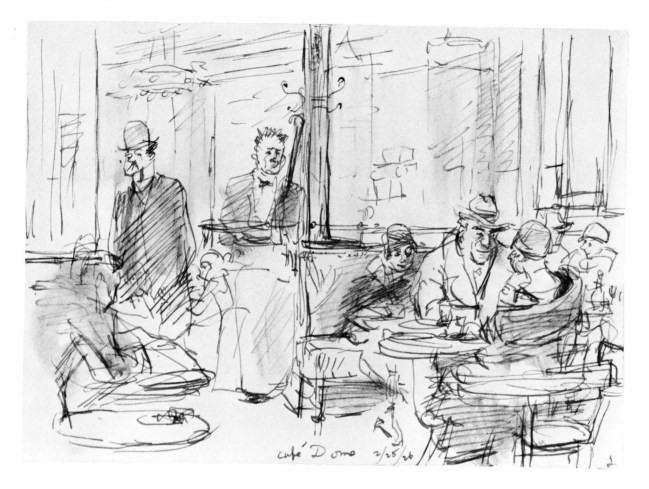

Café du Dôme, 1926.
Malcolm Cowley writes, "For ten years after the war, the Café Brasserie du Dôme de Montparnasse was truly 'the place.'" Marsh was born in an apartment above this café.

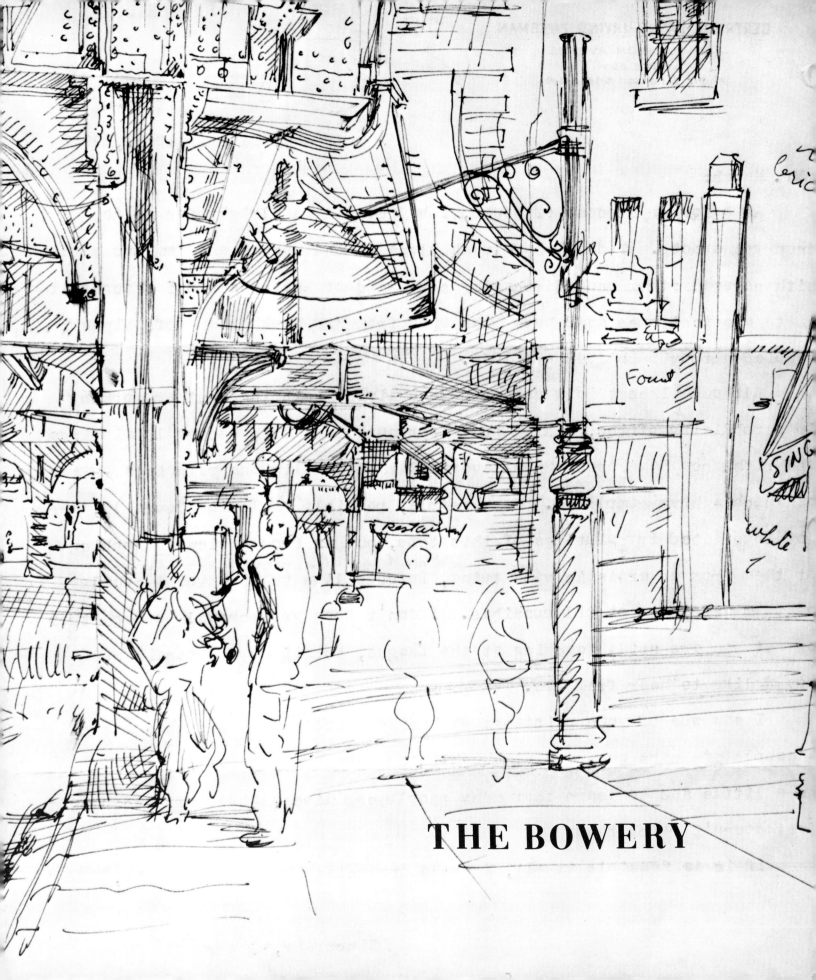

THE BOWERY

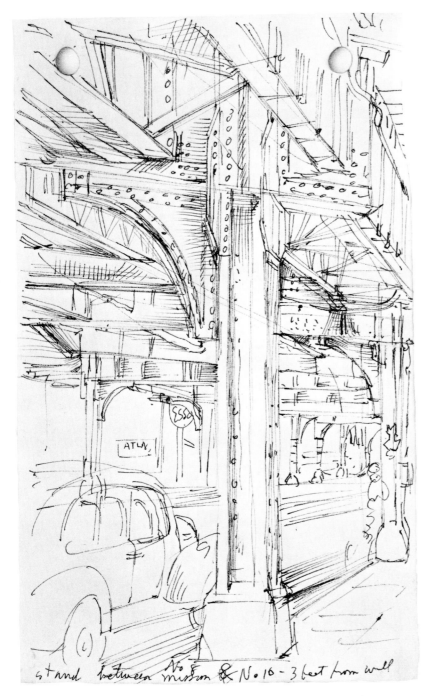

stand between mission & No. 10 – 3 feet from wall

The derelict, the vagrant, the bum—like the cowboy—is a perennial element in the American mythology. In the last century the outcast, the misfit, went West, across the wide Missouri, just as the despised and rejected of Europe had crossed the wide ocean to the New World in the first place. With the closing of the frontier in 1890, the tramp, the hobo, became a familiar figure in rural America, a part of our folklore. Charlie Chaplin gave him archetypal significance. In the cities this figure became the ubiquitous bum, from Seattle's skid row to New York's Bowery. He haunts the American imagination, perhaps the imagination of all men everywhere, with that *nostalgie de la boue* which is perhaps the obverse of the scramble for success. Marsh, although himself a man of means and of extraordinary self-discipline, was filled all his life with compassionate identification with this figure of failure.

The iron forest of the elevated railway at Chatham Square was the *mise en scène* of Marsh's Bowery. In this sketch he notes exactly where he is standing so that he can return to the spot for further observation.

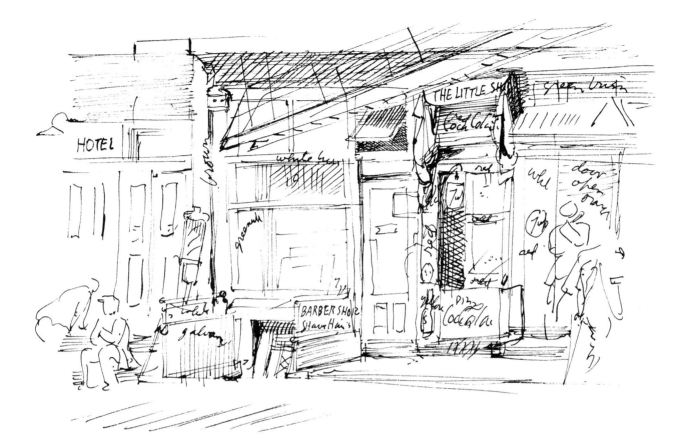

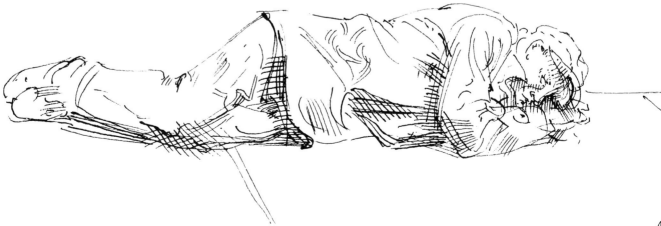

49

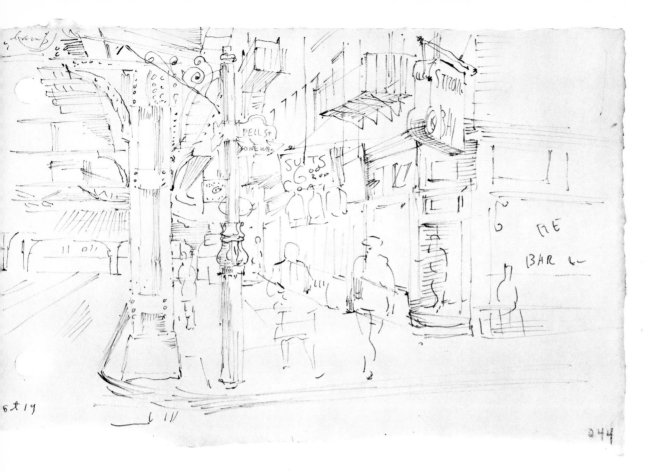

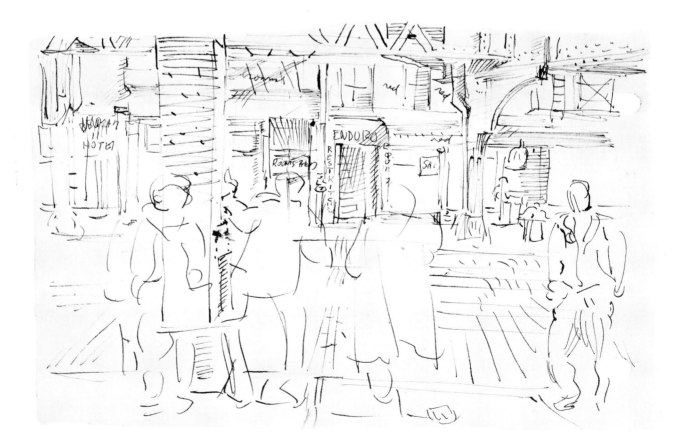

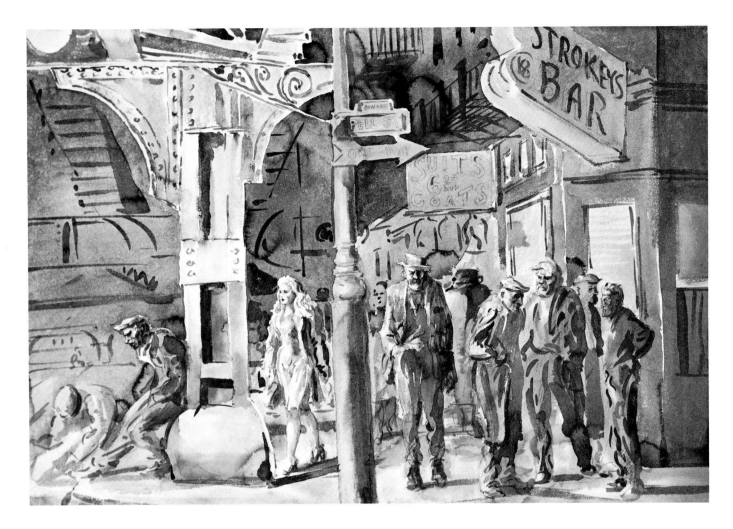

Strokey's Bar.
Chinese ink. Private collection.

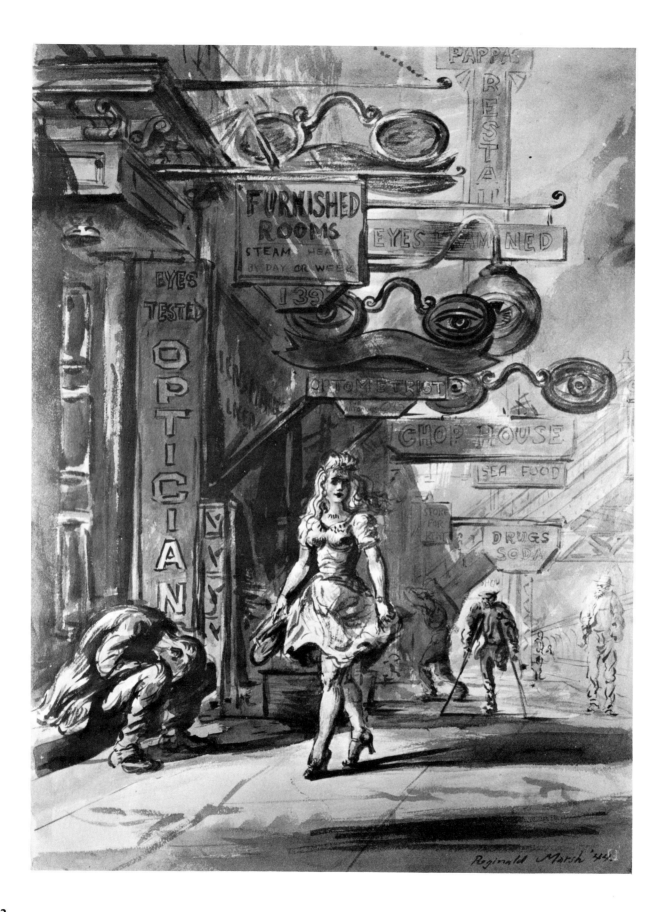

Reginald Marsh '44

Eyes tested.
Chinese ink and watercolor. Private collection. 1944.

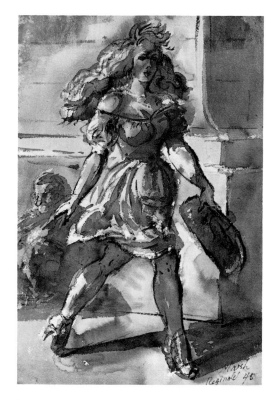

Girl with Pocketbook.
Wash drawing. The Rehn Gallery, New York. 1945.

She walks in beauty, like the night . . .
—Byron

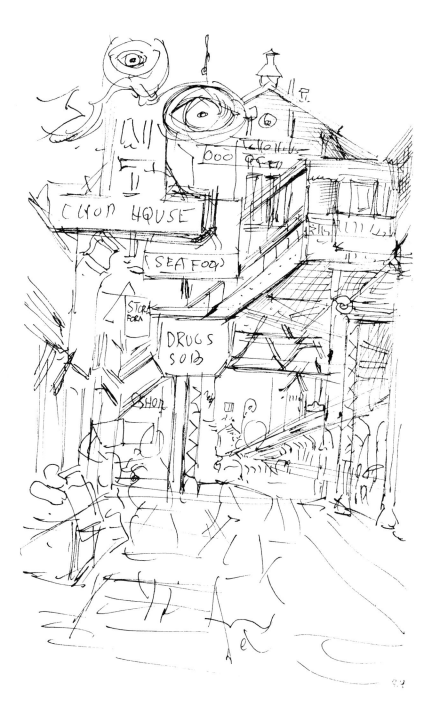

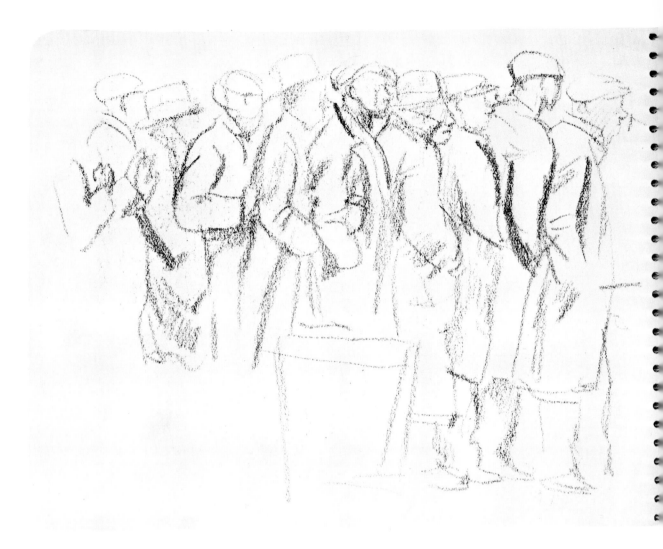

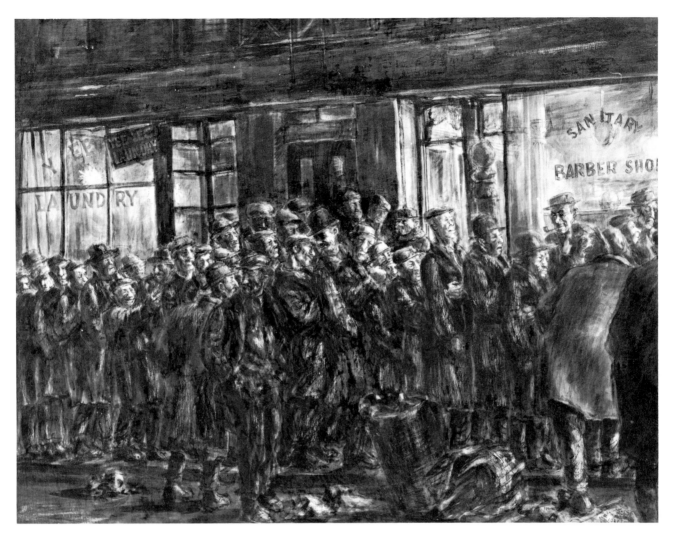

Holy Name Mission.
Tempera. IBM Corporation. 1931.

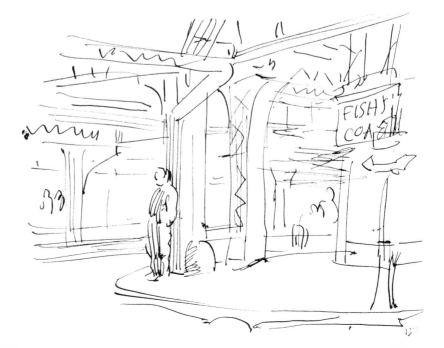

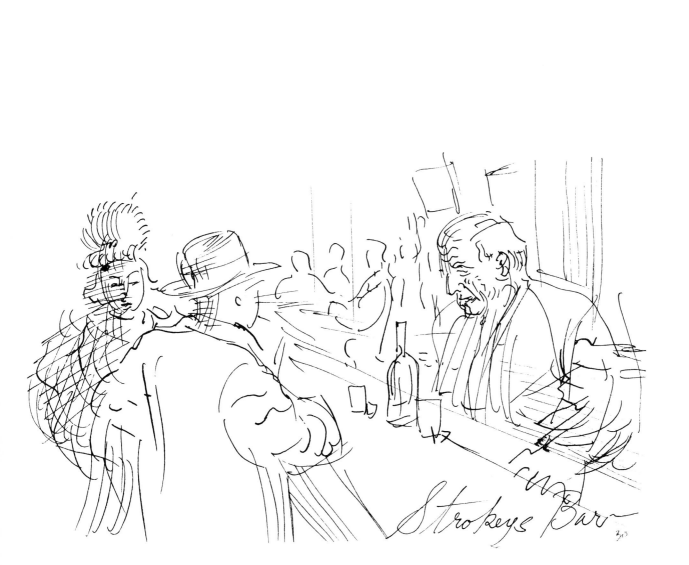

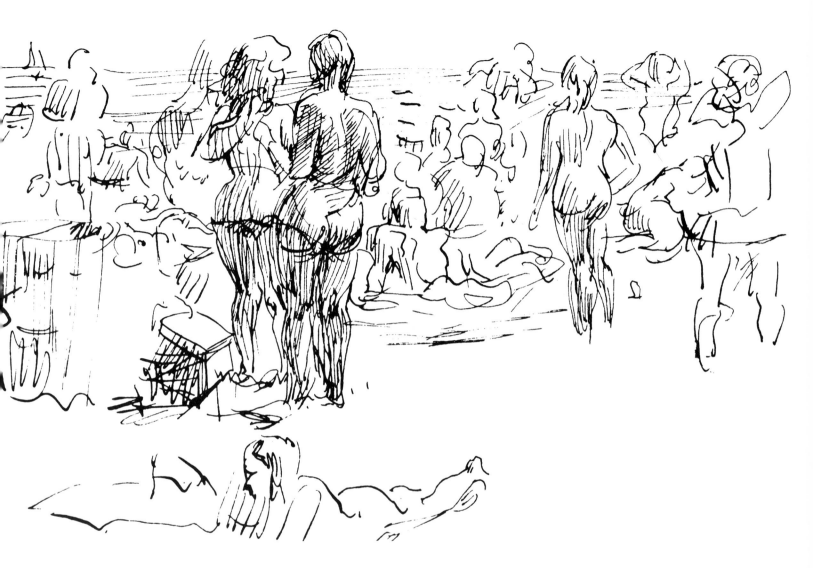

CONEY ISLAND BEACH

Marsh told me that one day in the Twenties the elegant and sophisticated Frank Crowninshield, editor of *Vanity Fair*, called him to his office and asked him to go out to Coney Island and make some sketches for the magazine. "It was the first time I ever went there," he said. This astonished me, for Marsh had made Coney Island so much his own that it seemed he had invented the place.

Of Coney Island Marsh said, "I've been going out there every summer, sometimes three or four days a week. On the first trip each summer I'm nauseated by the smell of stale food, but after that I get so I don't notice it. I like to go there because of the sea, the open air, and the crowds—crowds of people in all directions, in all positions, without clothing, moving—like the compositions of Michelangelo and Rubens."

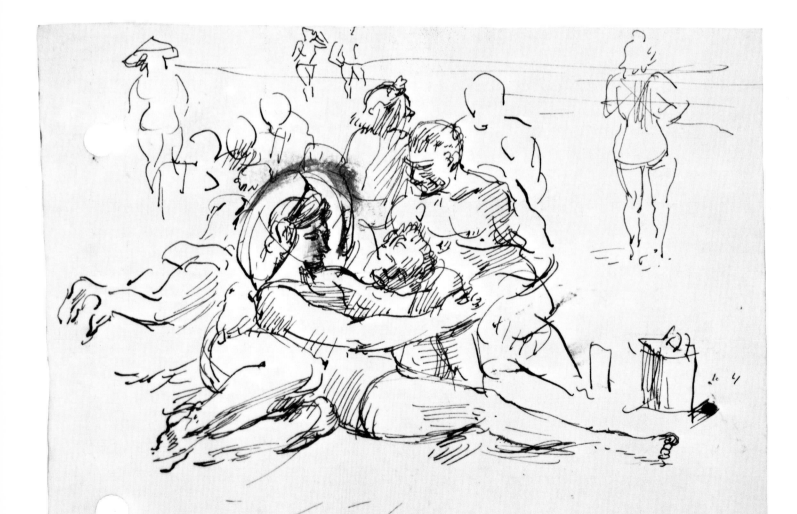

279

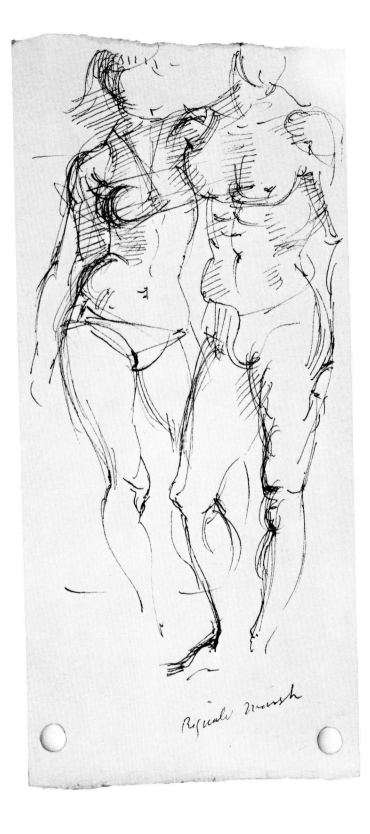

Reginald Marsh

2 couples

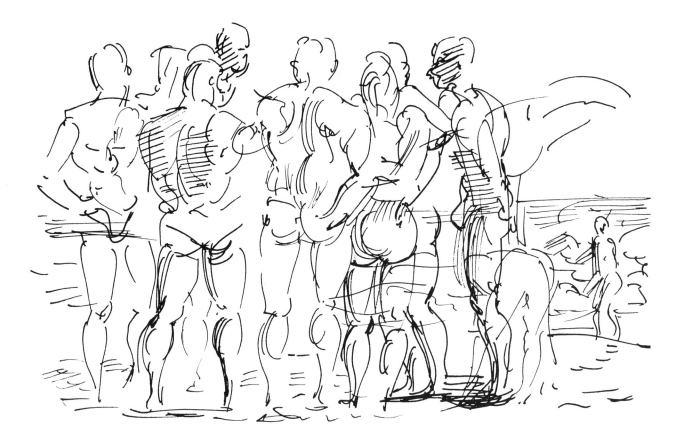

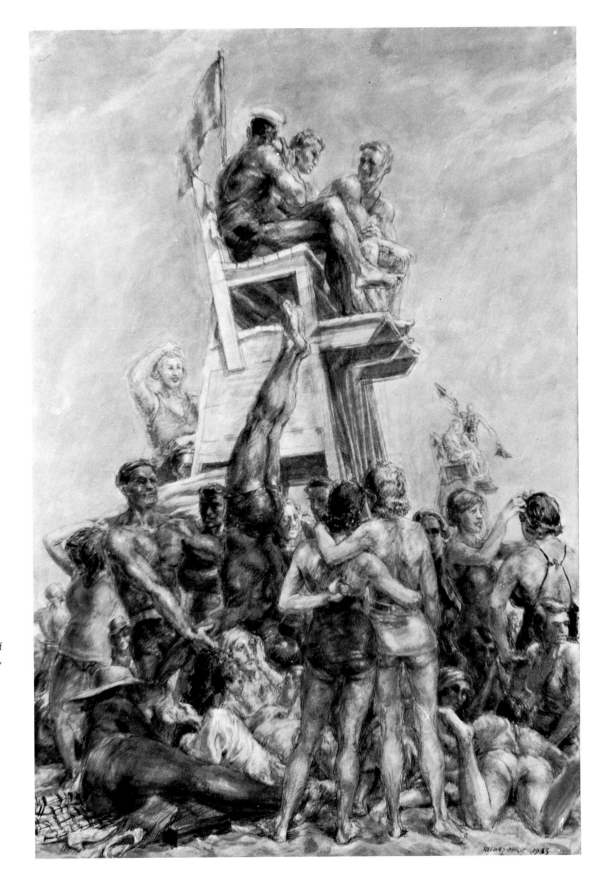

Lifeguards.
Tempera. Georgia Museum of
Art, University of Georgia,
Athens, Georgia. 1933.

sketched from life -
coney Island Beach,
August 1952 -

posed for by a weight
lifter and his lady
friend - in 5 mins

medium -
 waterman's
 artist pen - filled
 with Higgins
 "engrossing ink"

paper "Marilla" -

I carry these books
in the pocket every
day + pen
 Reginald Marsh

weight lifter pose readily - in exchange for sketches - Many men will
pose eagerly if a girl can be touched on
a desirable place

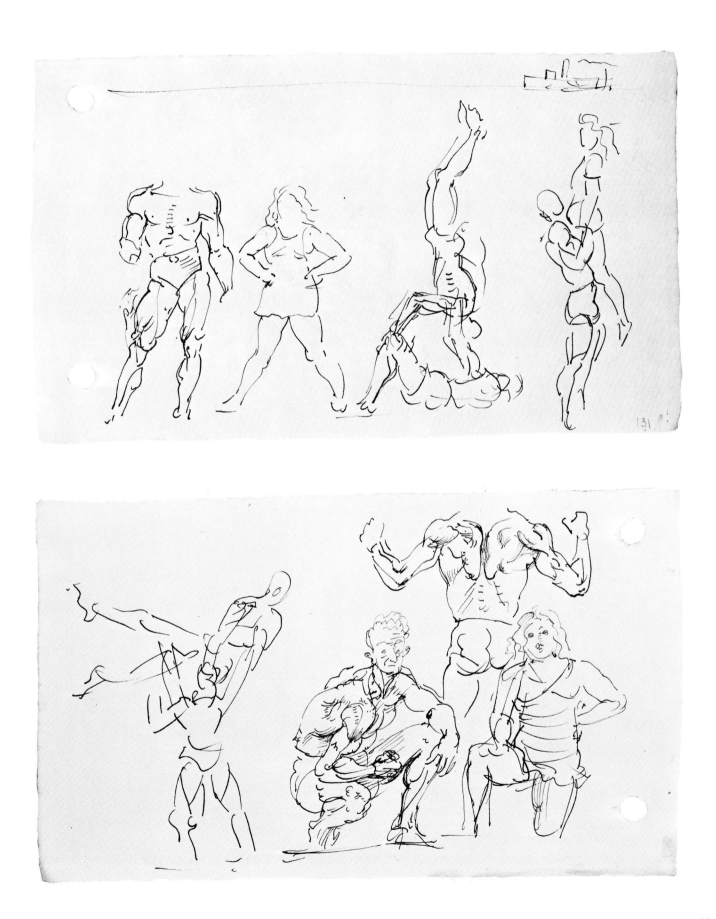

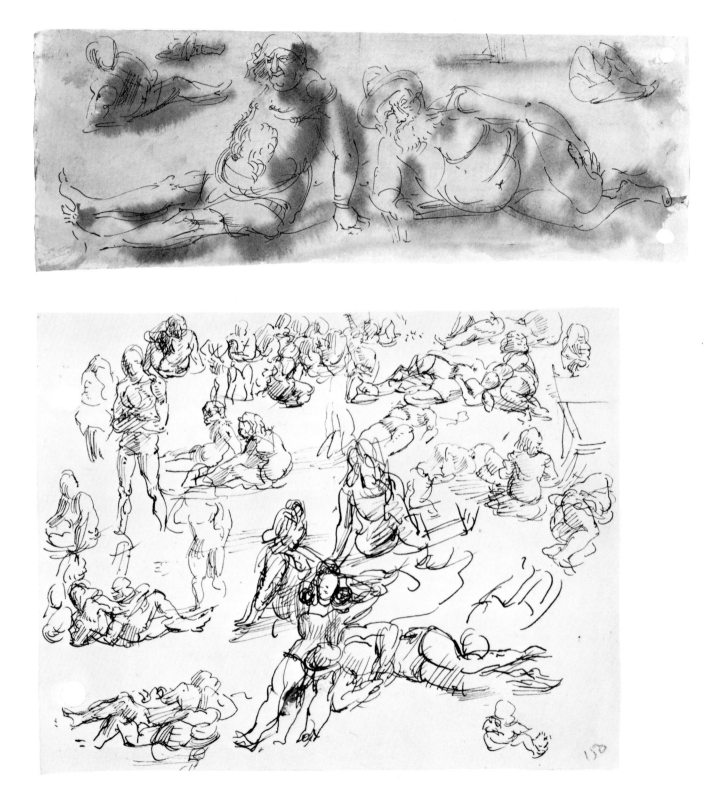

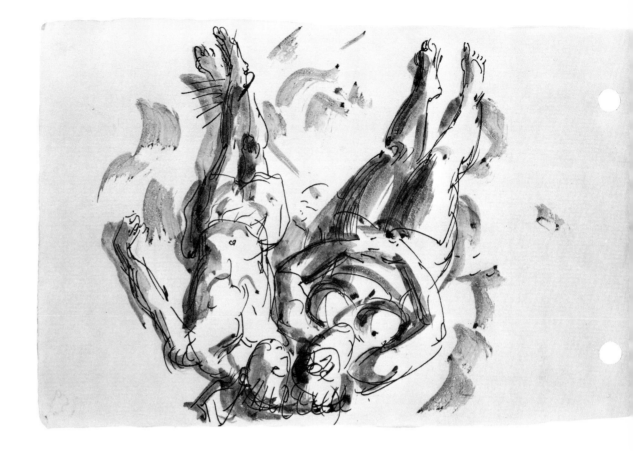

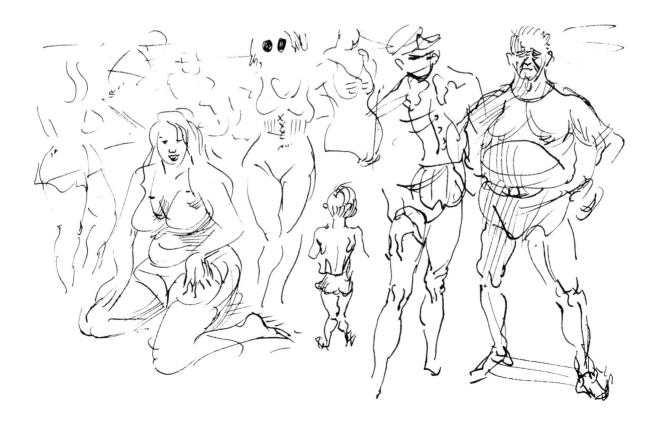

65

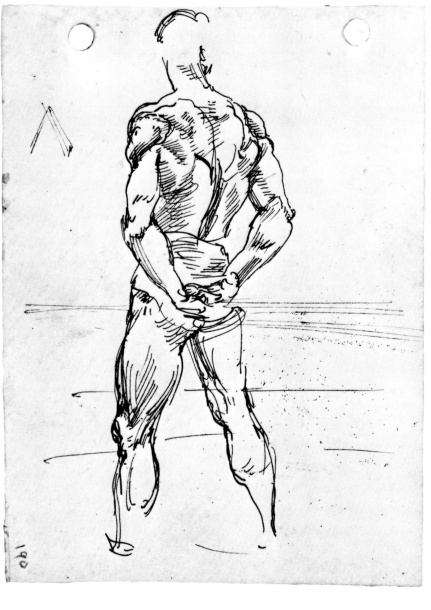

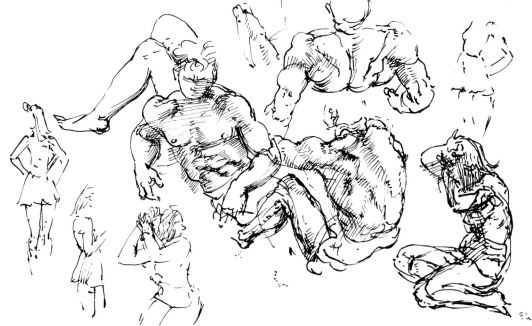

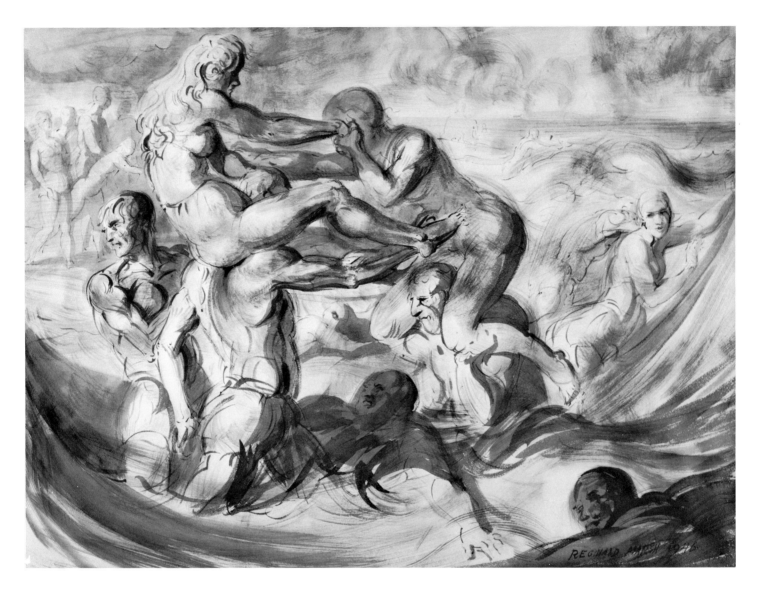

In the Surf—Coney Island.
Chinese ink. Collection of Mr. and Mrs. Lloyd Goodrich. 1946.

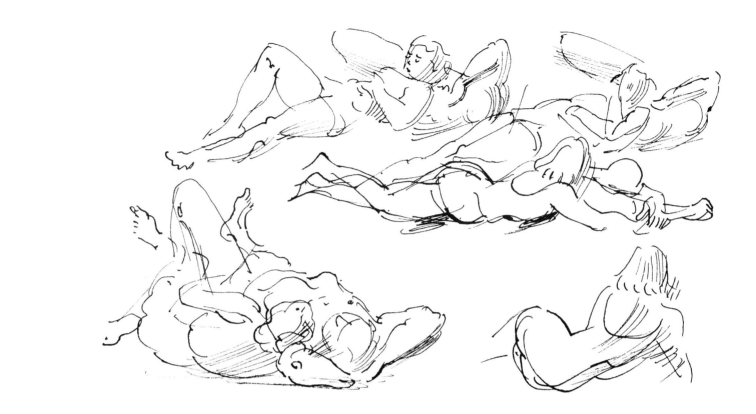

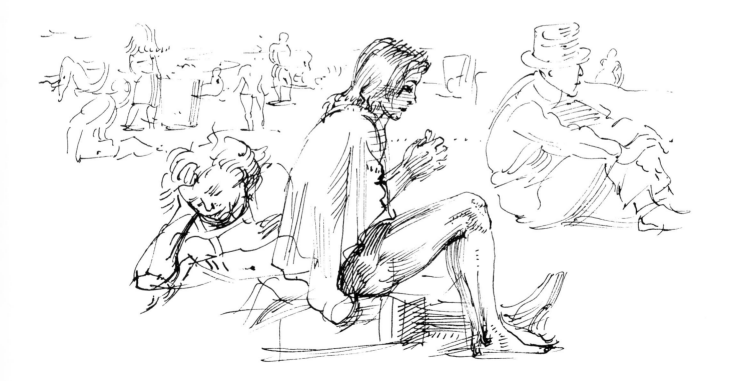

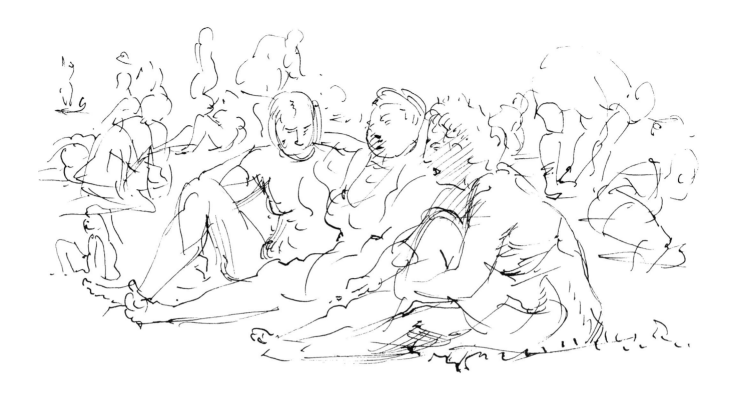

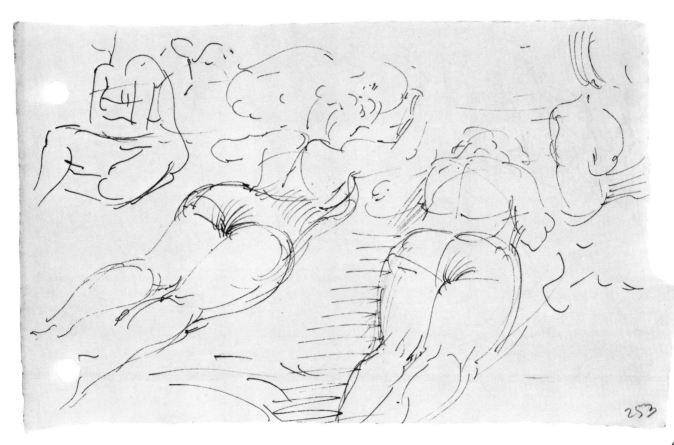

253

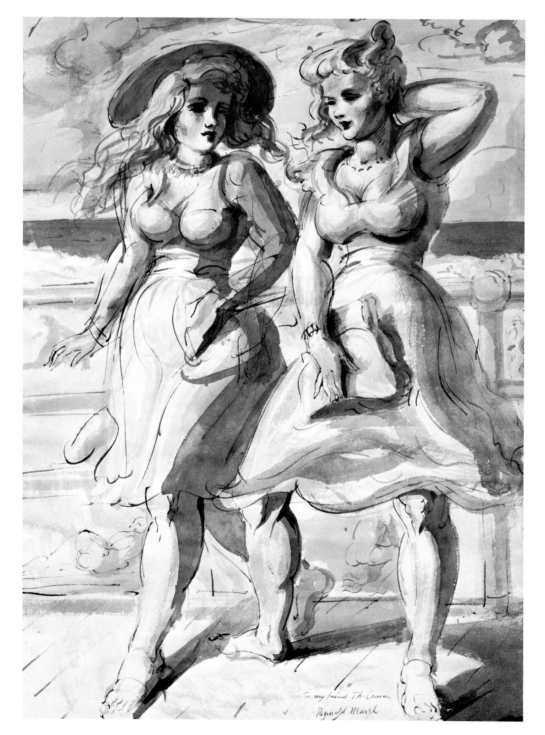

Two Girls on the Boardwalk.
Chinese ink.
Collection of Philip L. Dade.

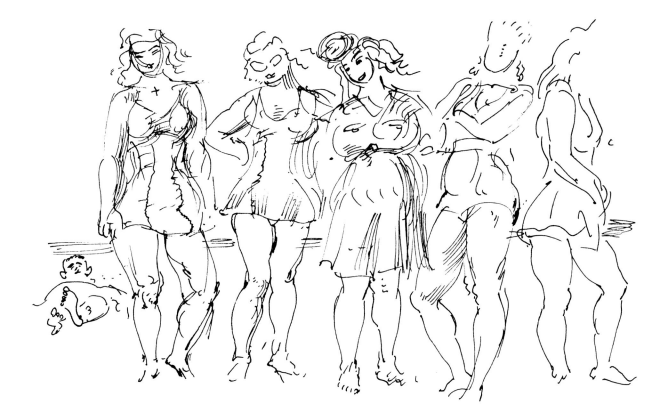

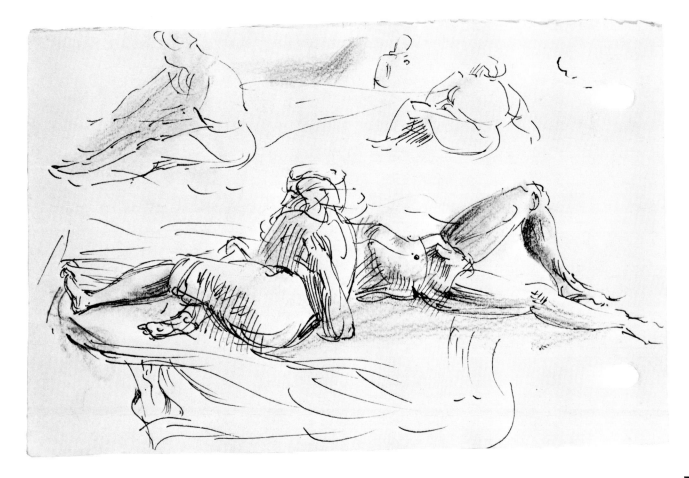

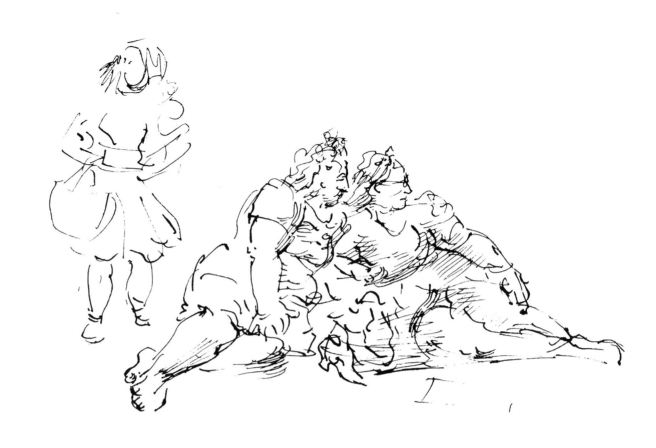

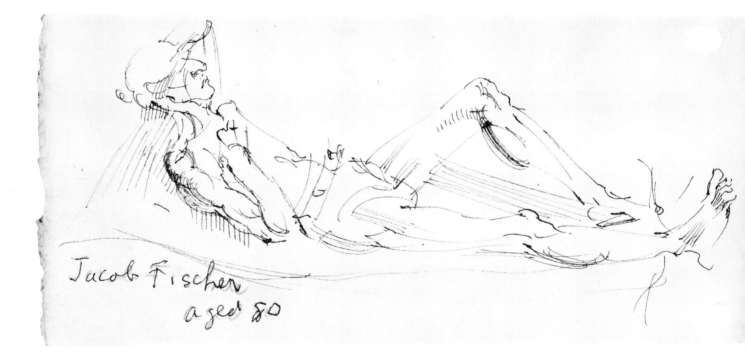

Jacob Fischer
aged 80

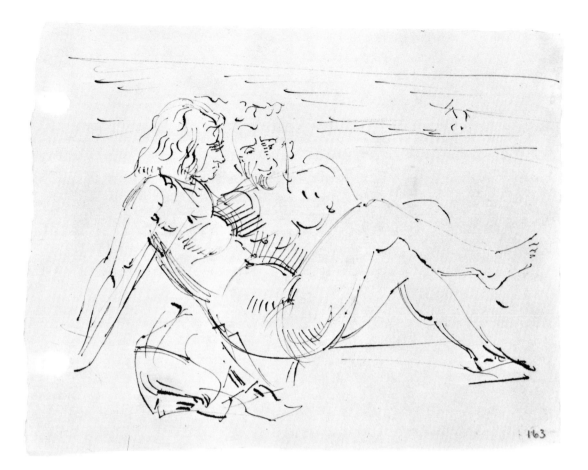

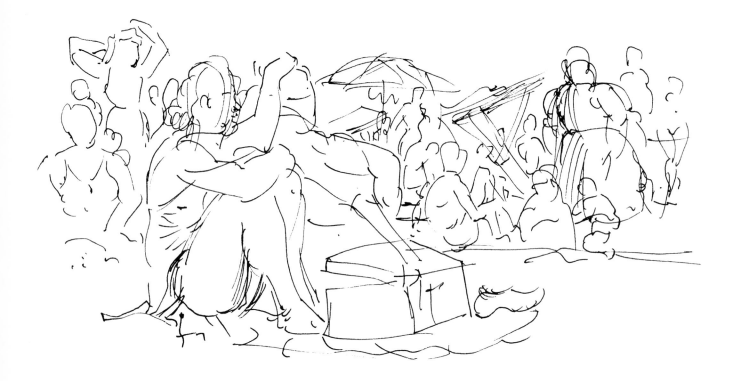

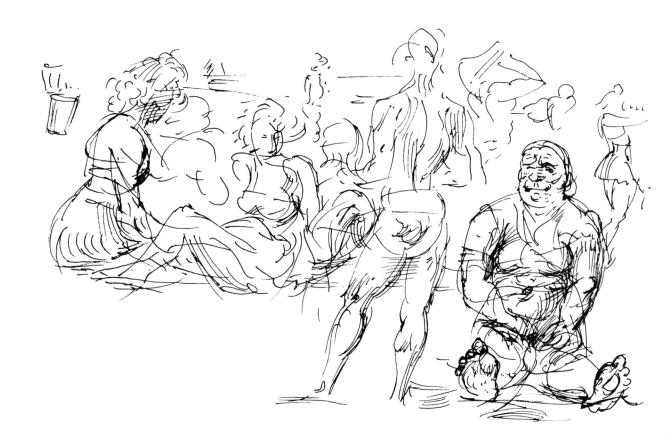

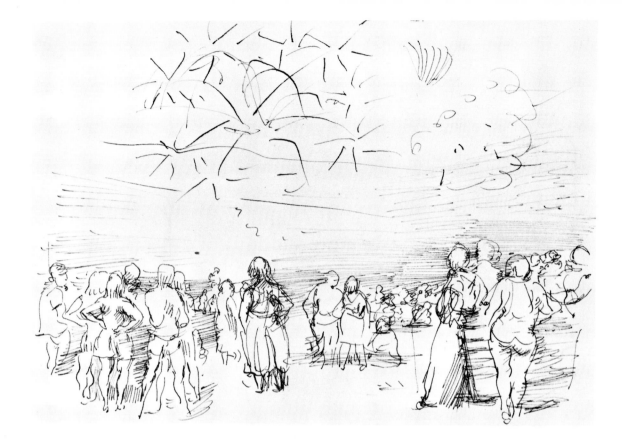

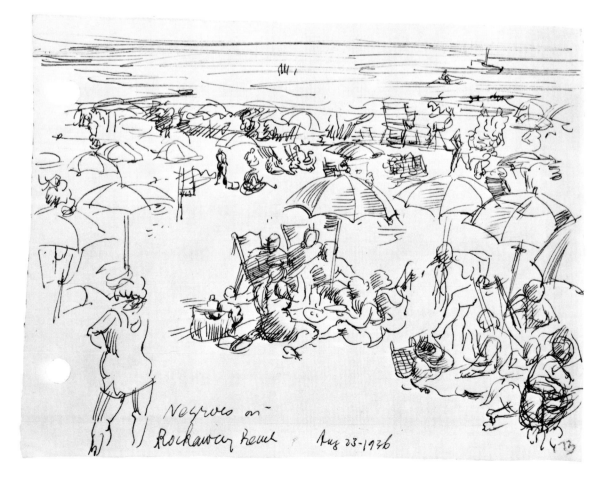

Negroes on
Rockaway Beach Aug 23-1936

Steeplechase—*The Funny Place*

"Steeplechase Park" at Coney Island has disappeared, as has its old rival "Luna Park." Both were concentrated areas of fun and games, glorified carnivals of chutes and slides, and "Tunnels of Love." Marsh enjoyed the circus, and boxing matches, but spectator sports appealed to him less than these boisterous arenas where the people amused *themselves*. At the opera, it was the *audience* that diverted him.

Girl on Merry-Go-Round.
Watercolor. Collection of
Mrs. Reginald Marsh. 1946.

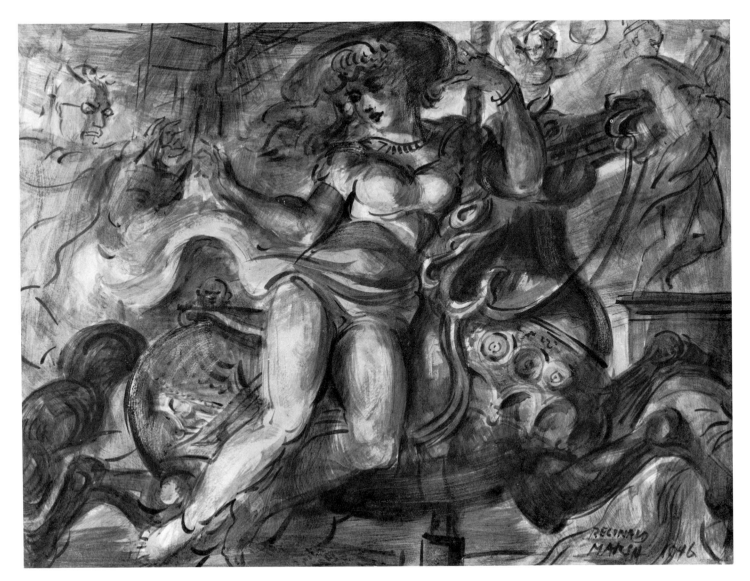

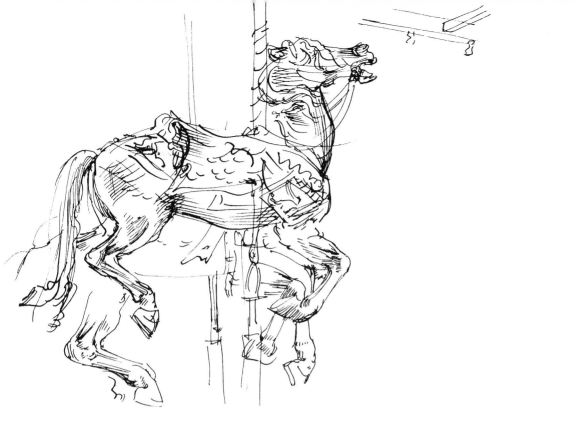

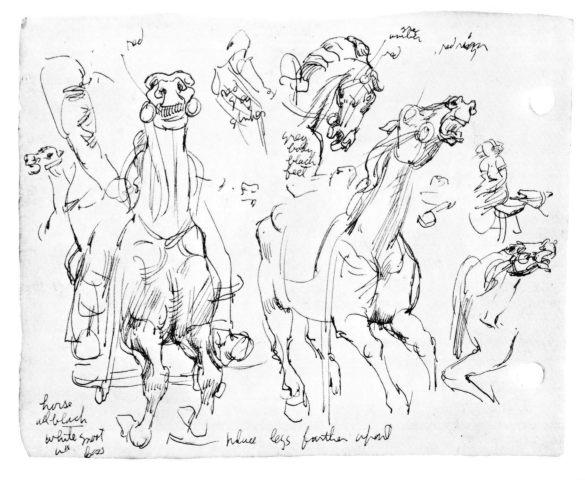

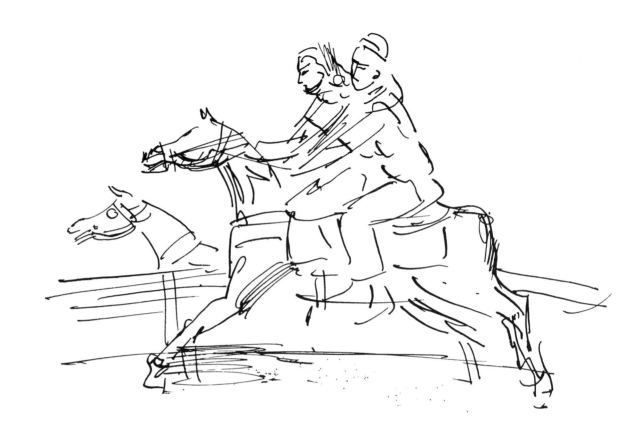

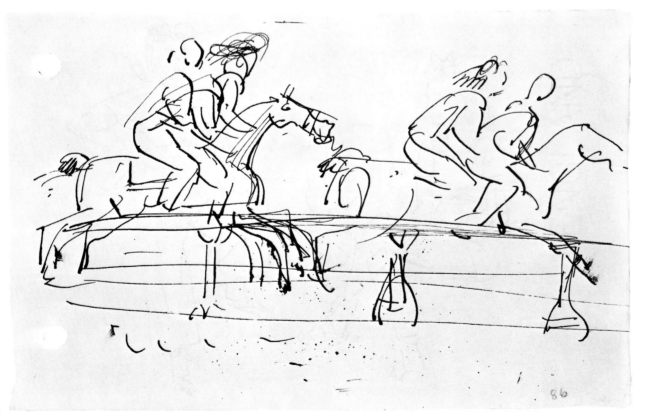

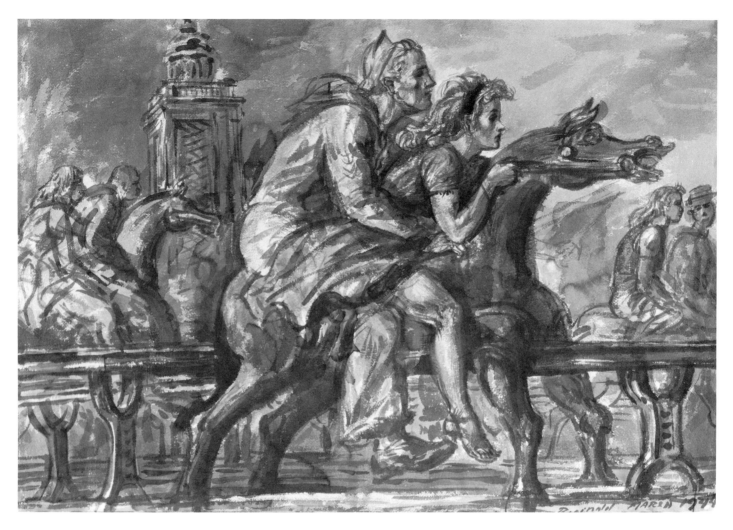

Steeplechase.
Chinese ink. Collection of Dr. Irving I. Burton. 1944.

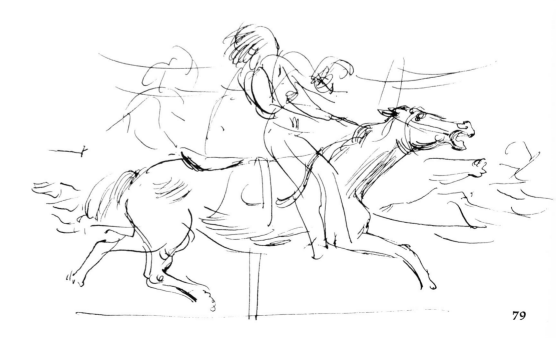

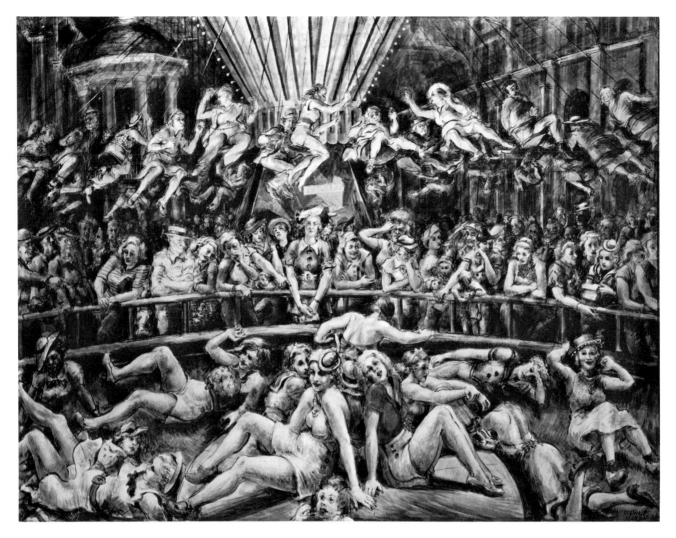

Steeplechase Park.
Tempera. The Joseph H. Hirshhorn Foundation. 1936.

Perhaps it is far-fetched (and certainly foreign to any conscious purpose of the artist), but it is fun to find here in Marsh's Steeplechase ("The Funny Place") the terraces of Dante's Purgatory or the concentric circles of Hell, and to discover Felicia, like Beatrice, at the center of this Divine Comedy—and over at the left, in the straw hat, his Vergil, his guide and teacher Kenneth Hayes Miller.

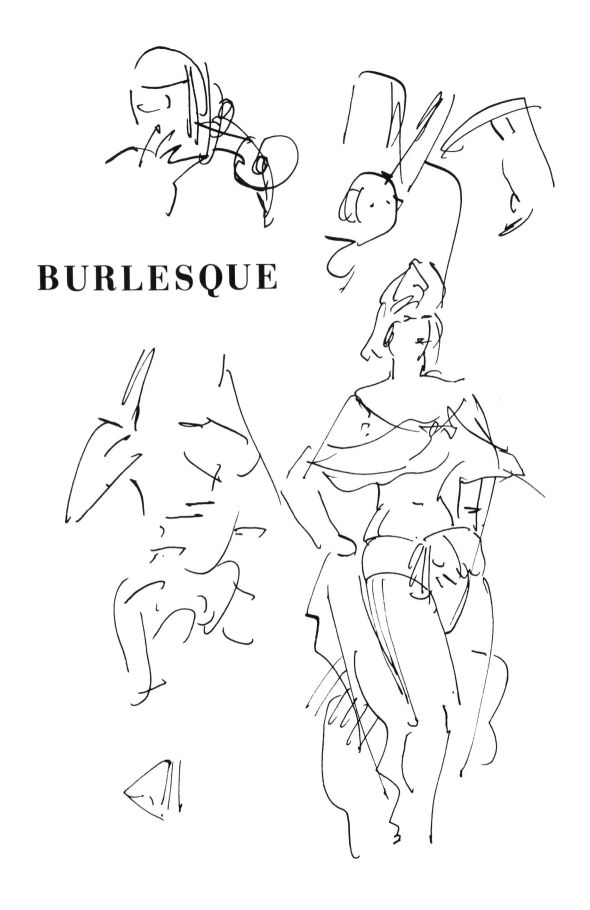

BURLESQUE

During Marsh's early years in New York, he drew for a newspaper, making drawings of theatrical acts and giving percentage ratings to these performances. In the 1920's, these "variety" shows, vaudeville and burlesque, flourished throughout the country. Burlesque was raunchy and vulgar, vaudeville more sophisticated. Acts in burlesque traveled from city to city on "The Columbia Wheel" in the same way vaudeville followed the Keith-Orpheum and Pantages circuits. I have been told that when "The Burlesque Queen," Ann Corio, was scheduled to appear in Washington, D.C., Justice Oliver Wendell Holmes had a standing reservation for a seat in the front row. All the greatest comedians of the day had their early training in burlesque and graduated to vaudeville just as the chorus girls of burlesque dreamed of finding themselves in the Follies. Marsh sketched clowns from the days of Grock and the Fratellini at the Cirque d'Hiver to Jimmy Savo on Forty-second Street; the girls from Dolly Dawson and Georgia Sothern to Gypsy Rose Lee.

Burlesque was "the theater of the common man"; it expressed the humors and fantasies of the poor, the old, and the ill-favored. But not all our leaders are as humane as Justice Holmes. Mayor La Guardia, the great liberal, was also a great prude. He ran burlesque out of the city. Marsh followed the exiled burlesque to Union City, New Jersey, and when he was forbidden, even there, to sketch openly, he drew inside his pocket! "Rose la Rose" is one of these blind sketches.

I believe Marsh was stage-struck always; he, too, was an entertainer. He appreciated the "higher" forms of theatrical art, but it was in its "lower" forms that he found what he needed. Out of vulgar burlesque he *made* great theater.

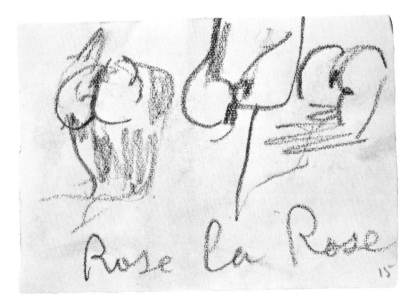

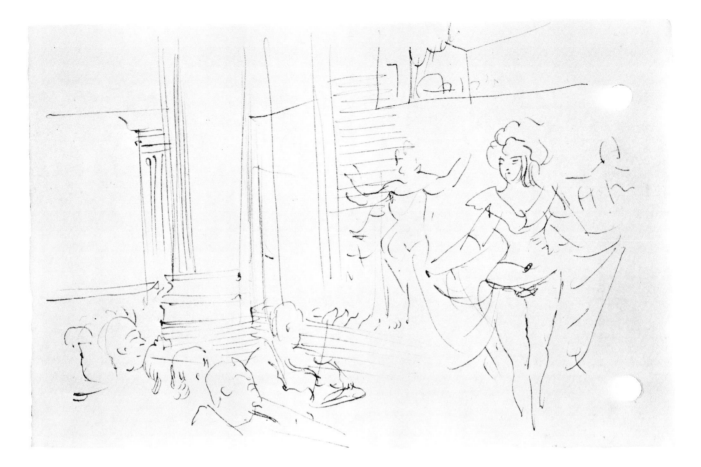

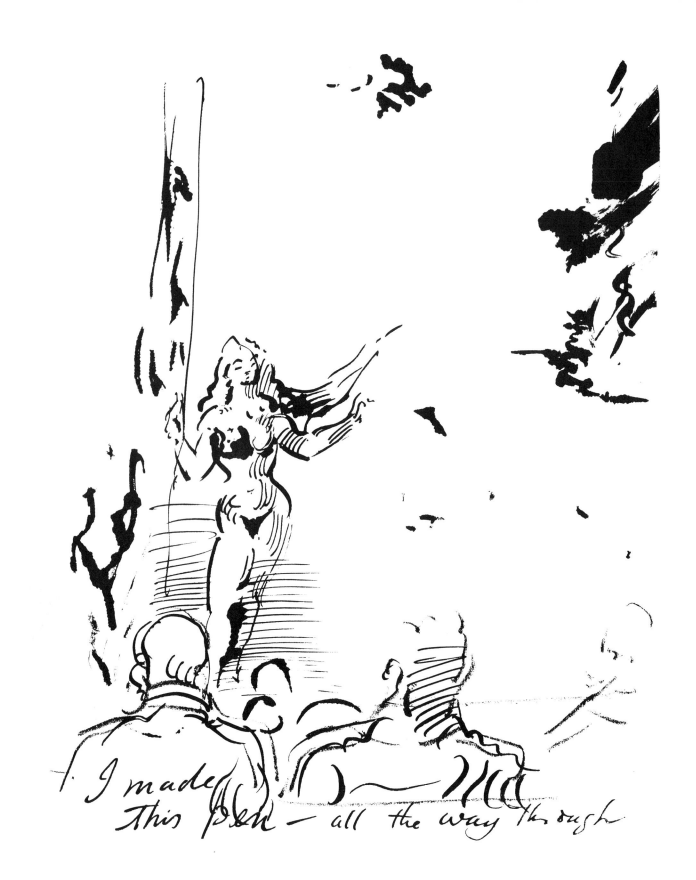

I made this pen — all the way through

Strip Tease in New Jersey.
Tempera. Estate of William Benton. 1945.

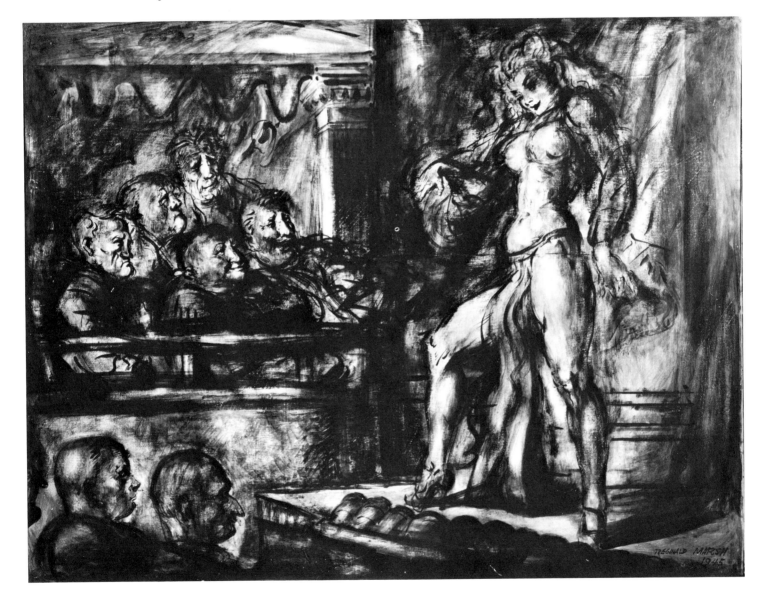

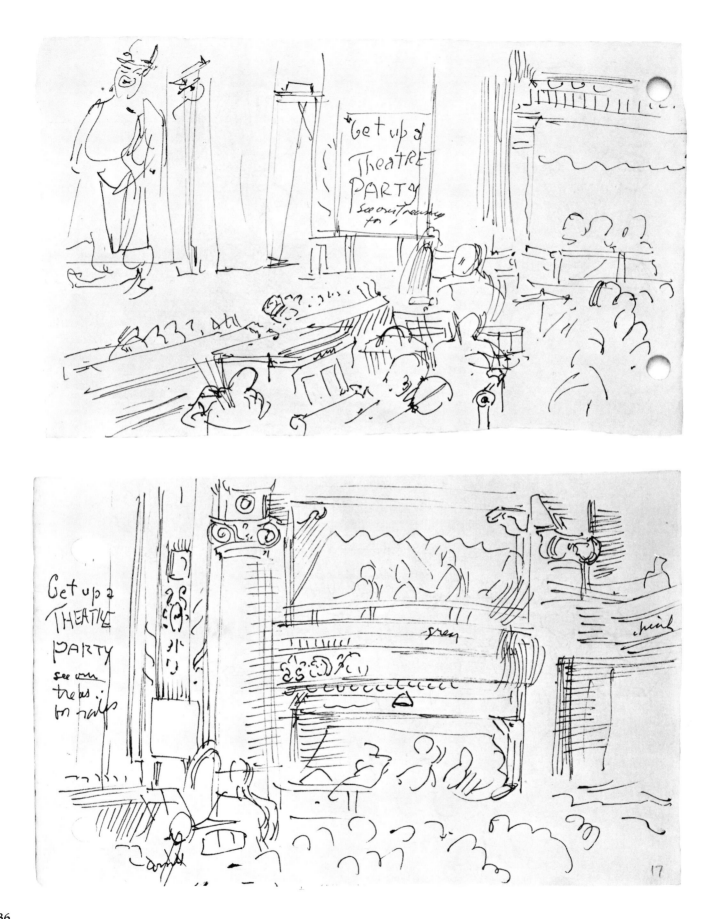

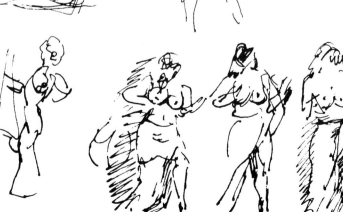

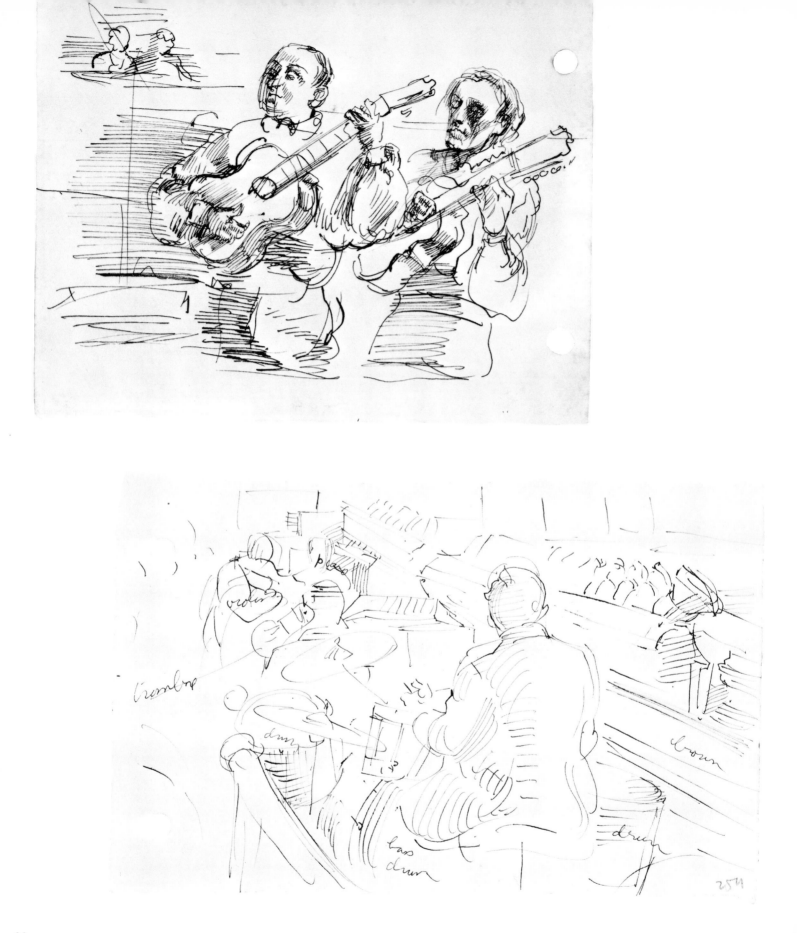

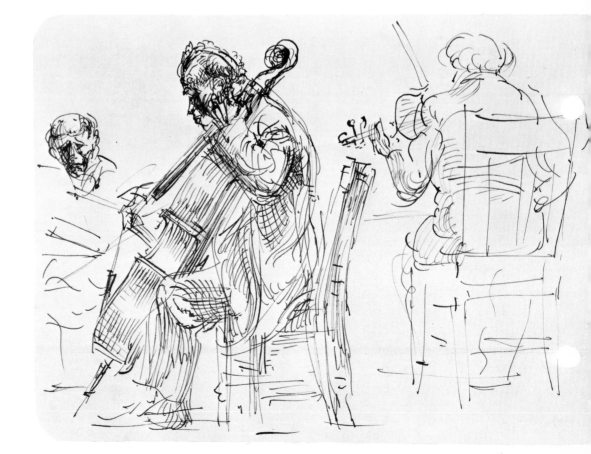

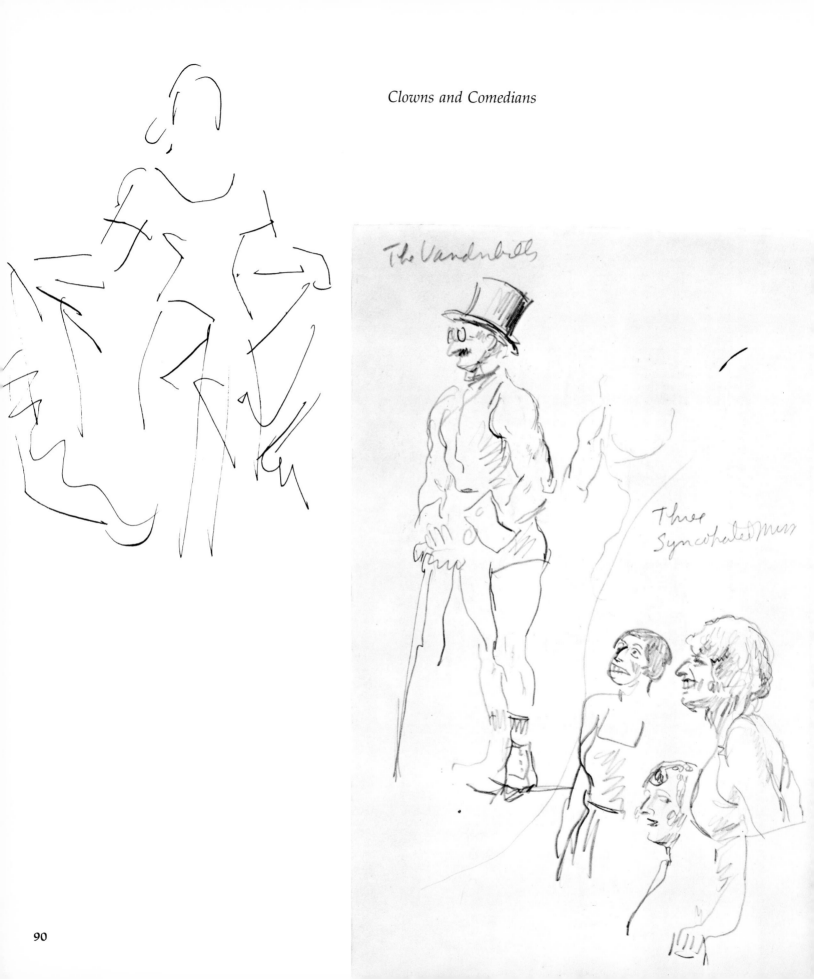

The Vanderbilts

Three
Syncopated Miss

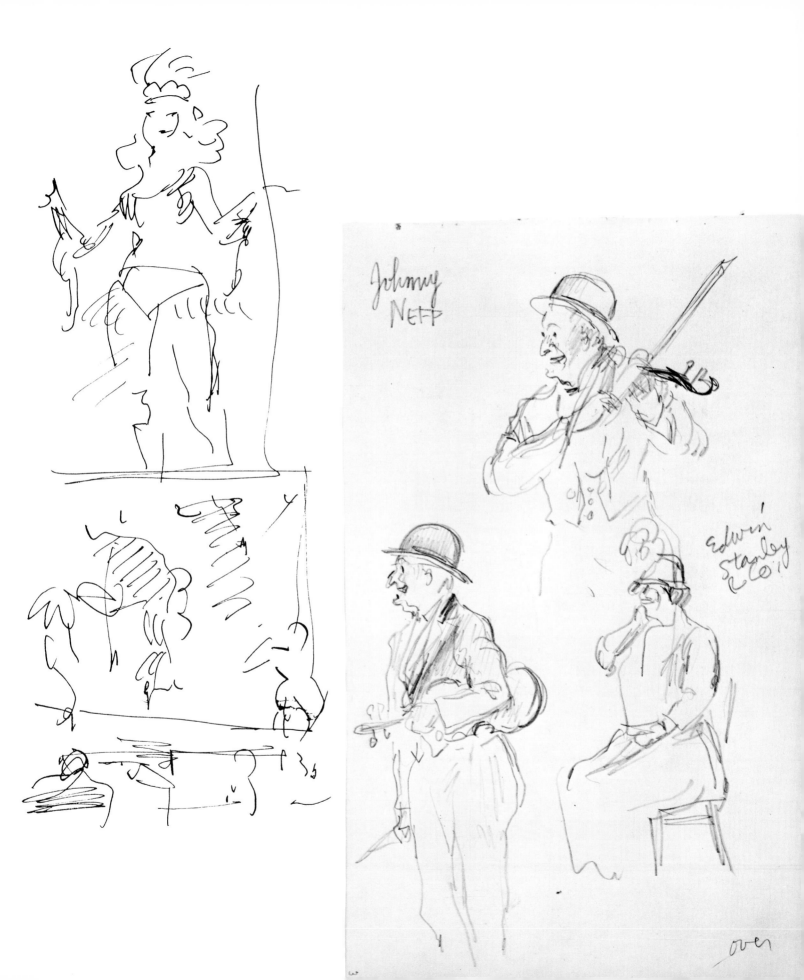

Johnny
Neff

Edwin
Stanley

over

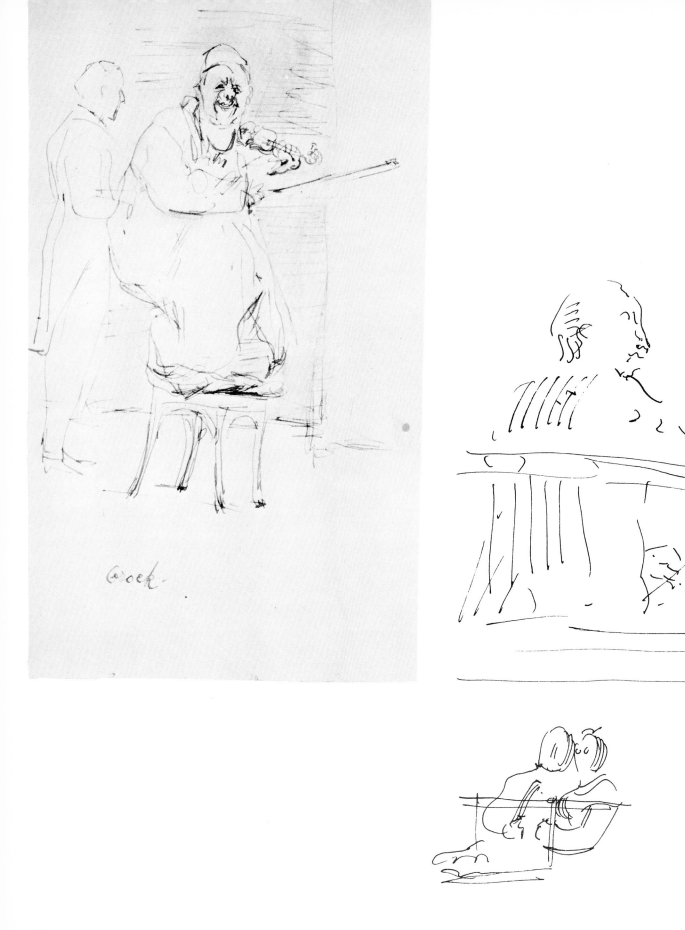

Grock.

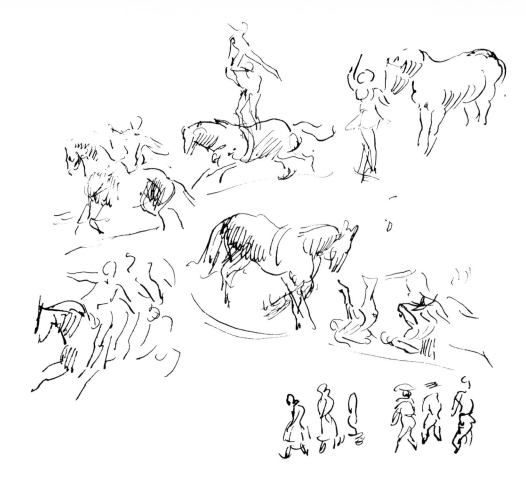

Circus

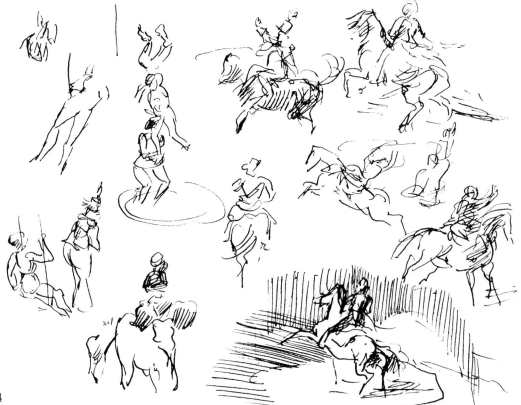

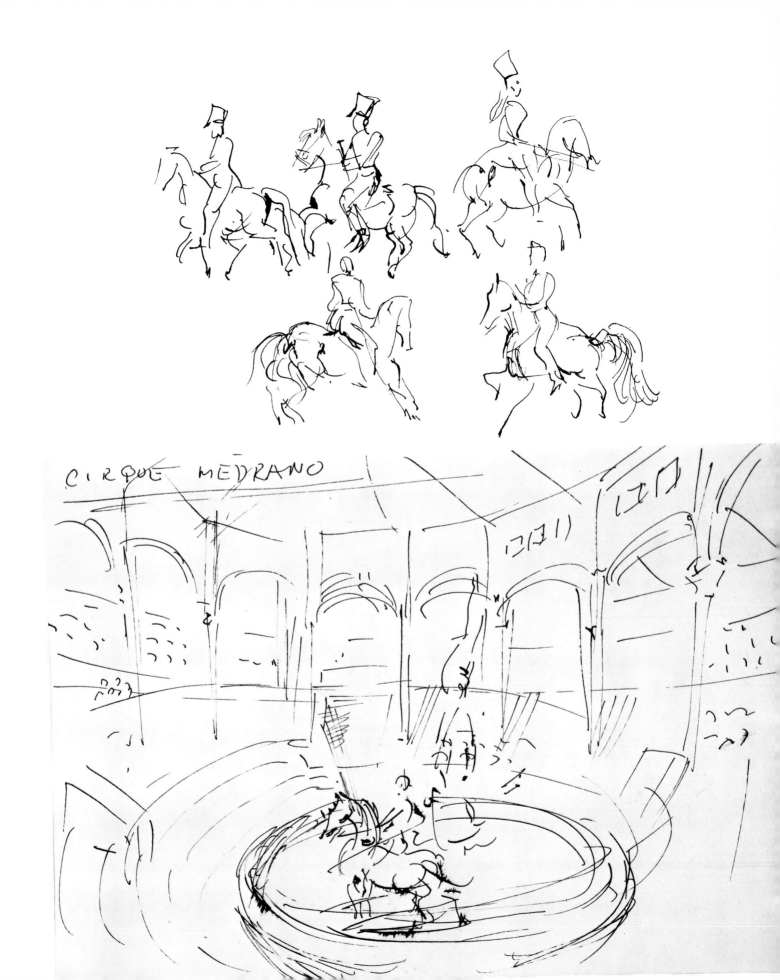

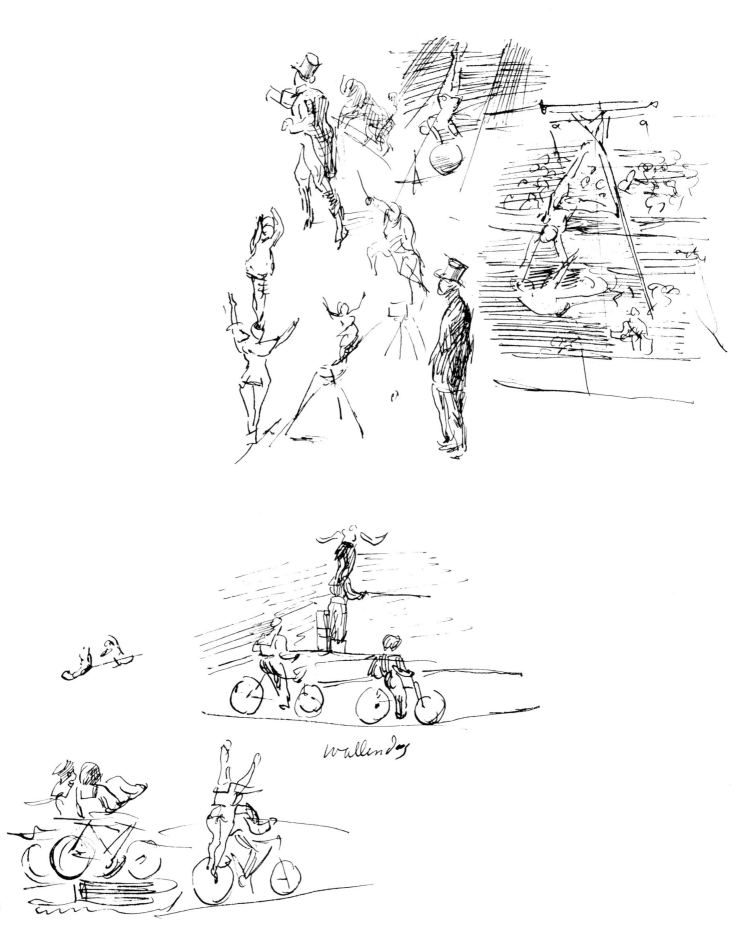

Wallendas

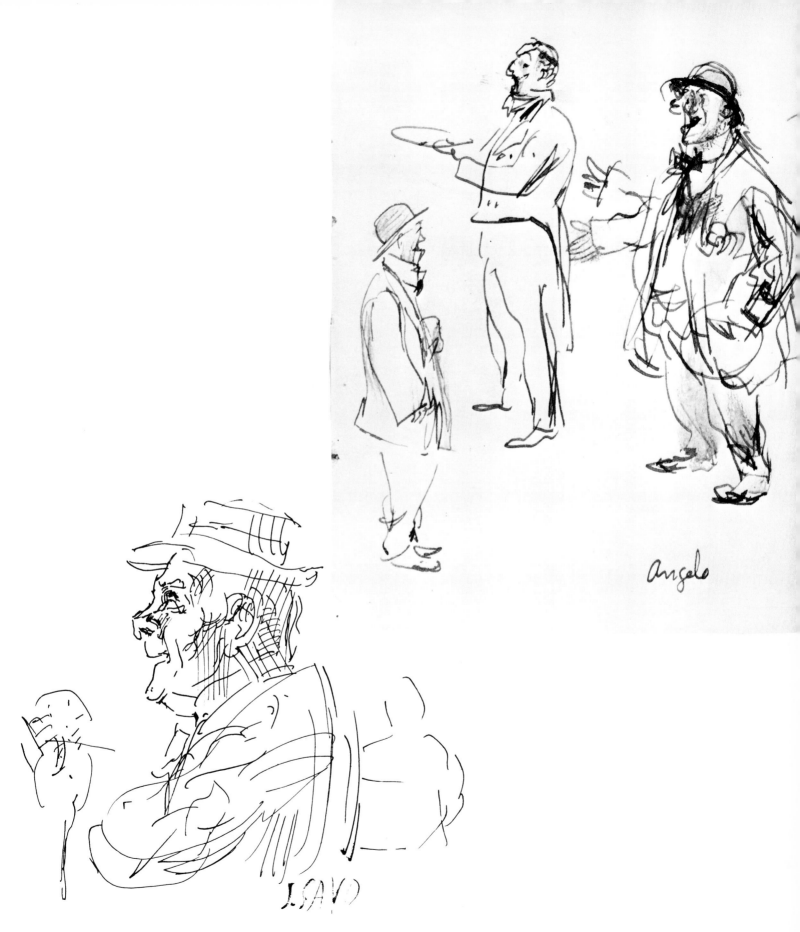

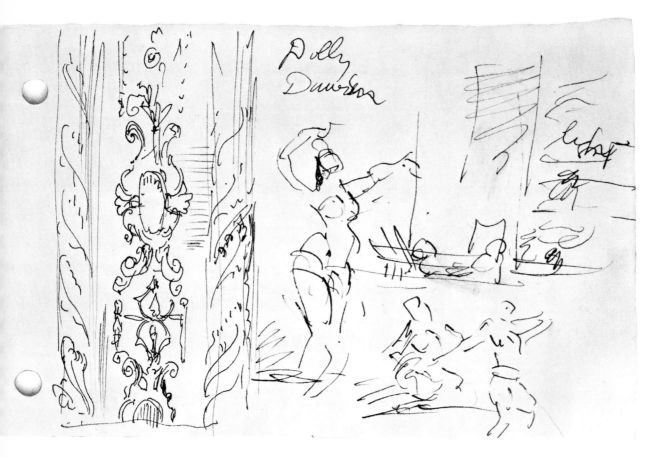

98

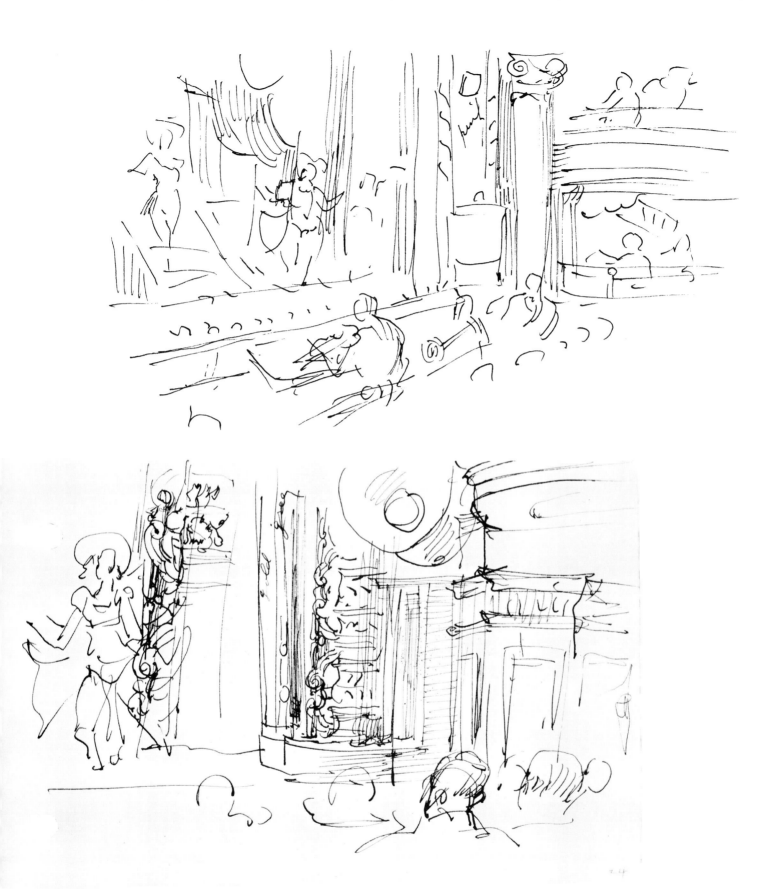

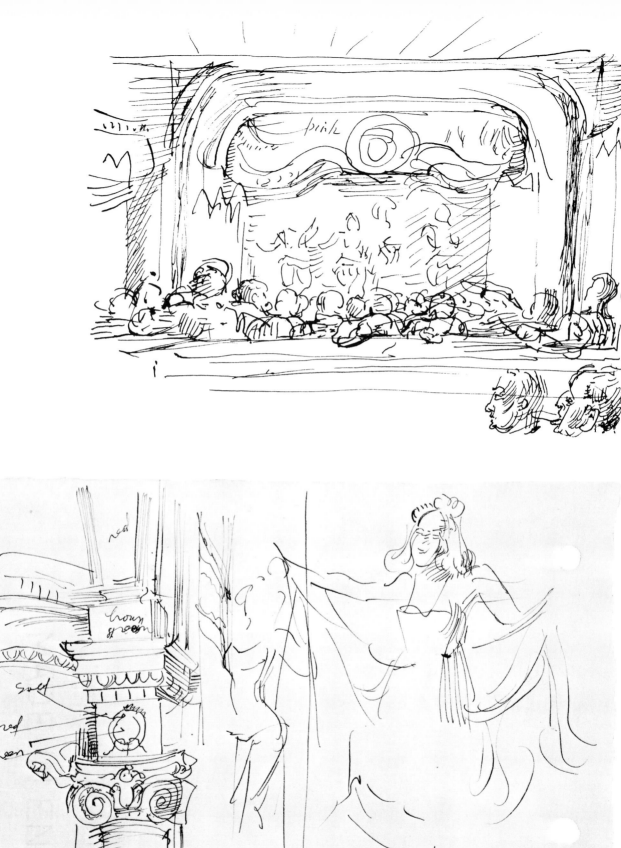

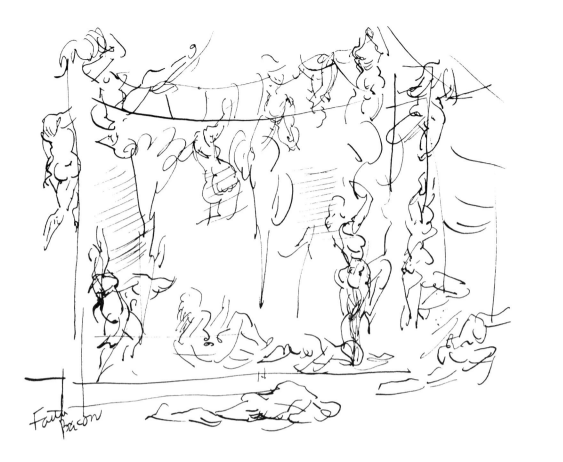

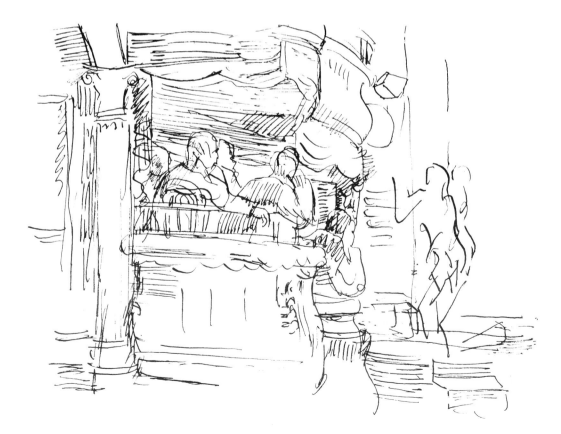

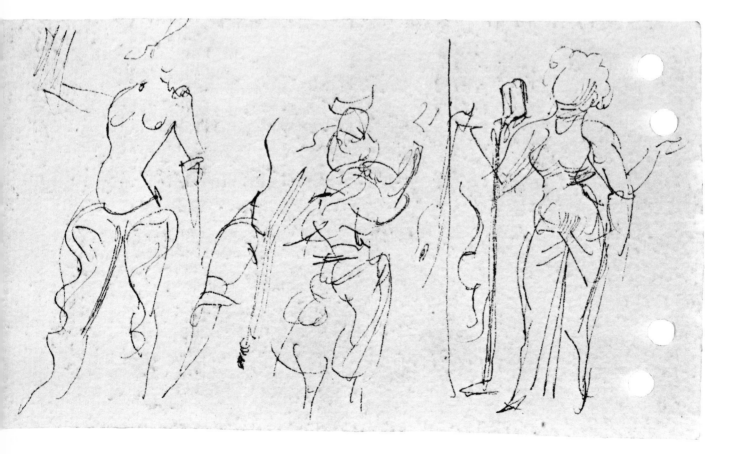

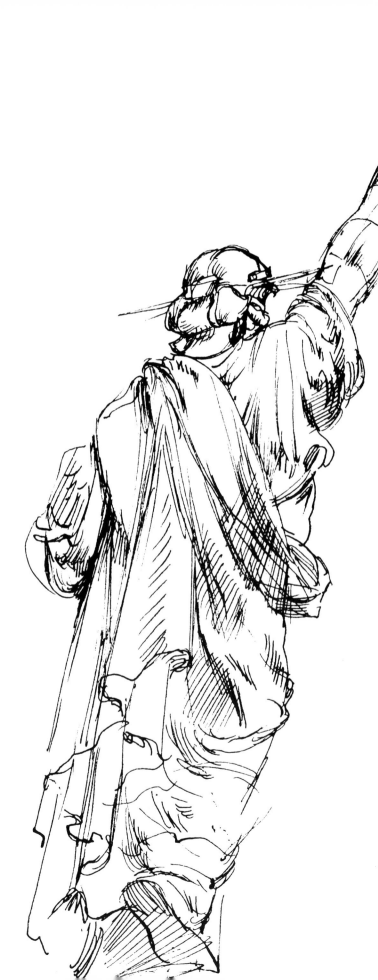

PORT OF
NEW YORK

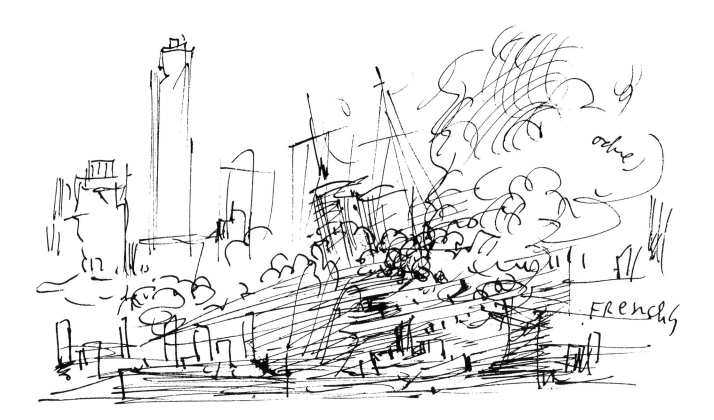

The burning of the "Normandie," February 9, 1942.

New York is above all a great seaport, and every aspect of the harbor fascinated Marsh. It was an inspired decision of the New Deal art program to commission him to decorate the rotunda of the U.S. Custom House in New York with murals depicting the busy maritime life of the city.

My wife Mary Fife and Lloyd Lozes Goff, who were among his assistants in this enterprise, have recalled for me some of their 1937 experiences. Mary says, "I would get up at three in the morning on a cold spring day and take the Broadway bus down to the Battery, where Reg would be waiting in the dark to board the tugboat which was going out to meet an incoming liner. I remember once he was wearing one red sock and one blue one—he had dressed in the dark because he didn't want to awaken Felicia! We were usually joined by reporters and press photographers going out to interview incoming celebrities. It was very close quarters because those little tugs are almost all engine, but the tugmen were always cordial and gave us coffee against the cold harbor wind. We would meet the steamship out near Coney Island and go aboard, sometimes through a door in the ship's side and sometimes by climbing a rope ladder. At first it embarrassed me to climb straight up above the men, but Lloyd reassured me. "They bow their

heads," he told me. Often we were invited to breakfast on board the liner. Then, while the newspapermen interviewed the celebrities, we would sketch."

Lloyd writes, "There were briefing sessions in Reg's Union Square studio. We made sketches and color notes in watercolor from his composite layouts to familiarize ourselves with his designs and techniques. I was also asked to do tempera painting on gesso panels using a thin wash technique to prepare for the 'fresco secco' we were to do on the walls.

"In those days the harbor was very busy and we were sent down to Battery Park to make detailed sketches of rigging, tugboats, the Statue of Liberty, and the skyline from Governor's Island. We often accompanied Reg on trips to meet the 'Queen Mary' or the 'Normandie.' We sketched during the trip up the North River and during the docking. Reg wanted details of lifeboats, davits, hawsers, ventilators, stacks, masts and rigging, sirens, bells, deck-chairs—everything. It was all to be annotated as to which, where, when, etc. He was a strict boss and could become nasty if he thought we were shirking—he was much more of a disciplinarian than, say, Laning or Cadmus, whom I also assisted.

"Two particular harbor trips I enjoyed the most. One was an overnight stay on Ambrose Lightship. We ate and talked with the harbor pilots who lived there and from there boarded and debarked from ships entering and leaving the Port of New York. It was a rough, rich experience. We made sketches of every part of the lightship.

"Then, another time, we spent a day on the boat that serviced the lights and buoys of the entire harbor. There was a tough young crew that hauled buoys out of the water and replaced them. They boarded other buoys to fix lights and whistles, all the while bobbing up and down in the choppy seas. All of the crew were very much interested in our sketching and diverted by our day with them. It was pretty wonderful."

Hudson River pier.

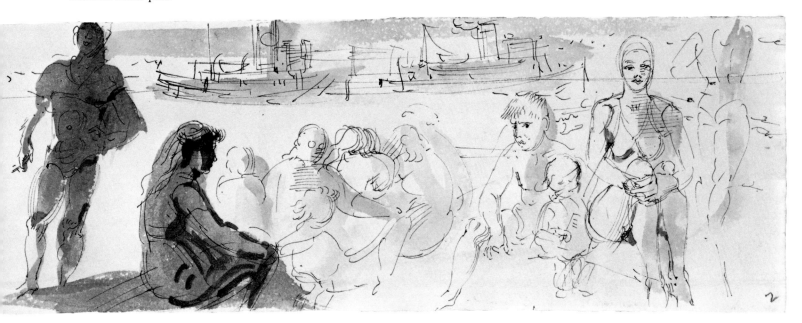

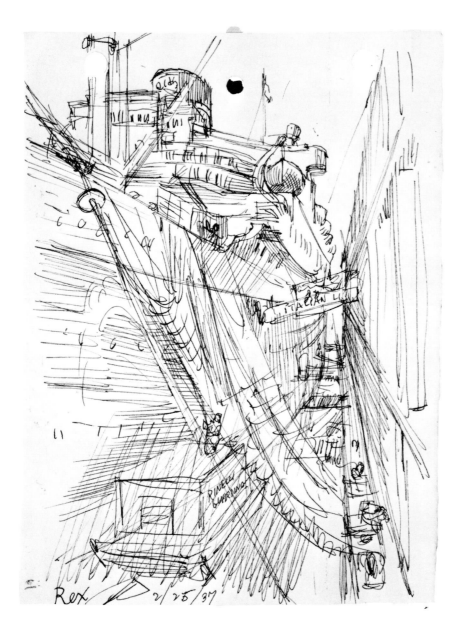

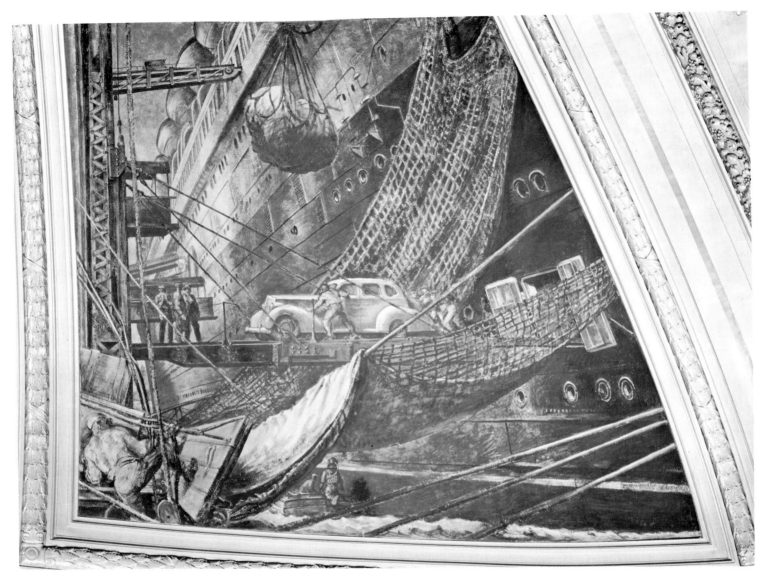

Unloading the Cargo.
Fresco secco. Mural in the rotunda of the Custom House, New York. 1937.

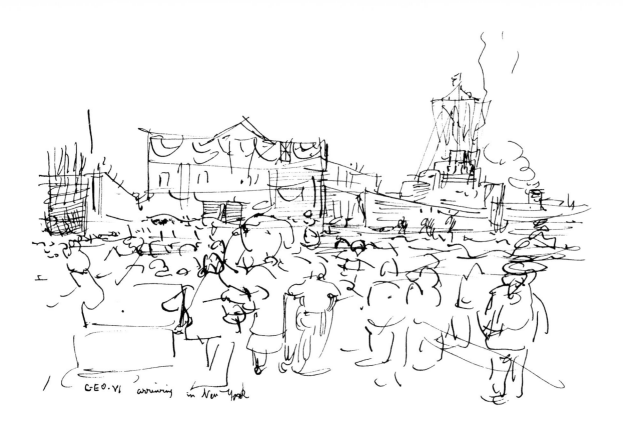

GEO. VI arriving in New York

docking south Meredi
Oct 14 - 1935 side of by Dalzel Meseal Bonef

The several tugboat companies
which helped to dock the great
ocean liners are identified on their
stacks and at the bottom of the
sketch. Marsh came to know their
captains and crews well.

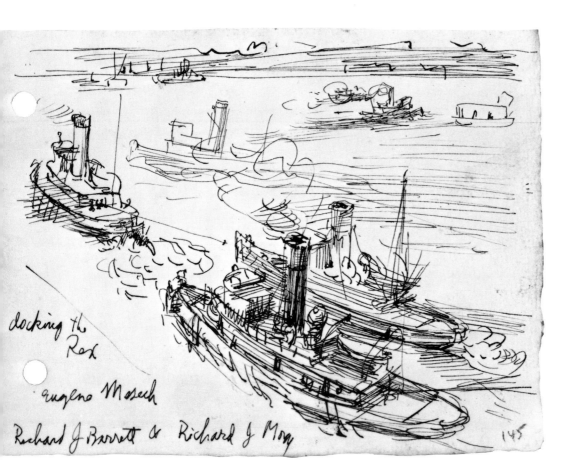

docking the
Rex

eugeno Mosech

Richard J Barrett & Richard J Moran

145

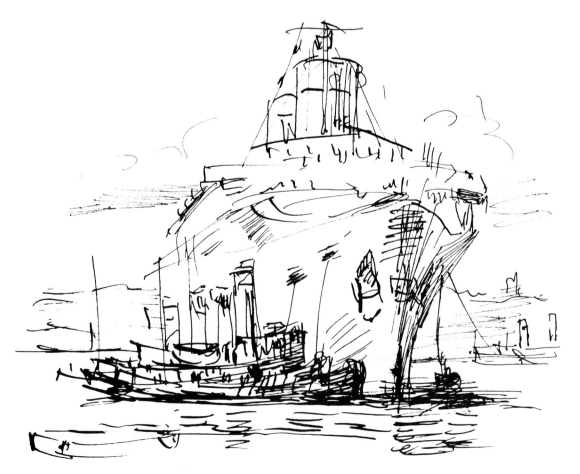

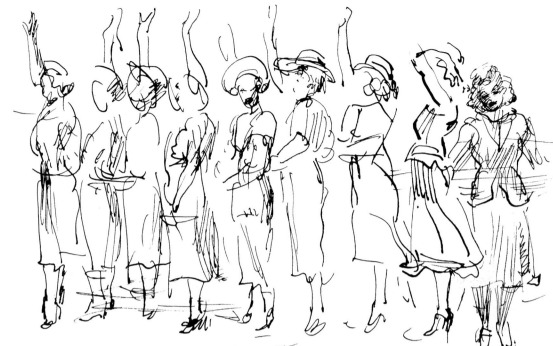

The shipboard interview with celebrities arriving in New York has passed from the scene. Here Marsh depicts the Radio City Music Hall Rockettes as they return from a European tour.

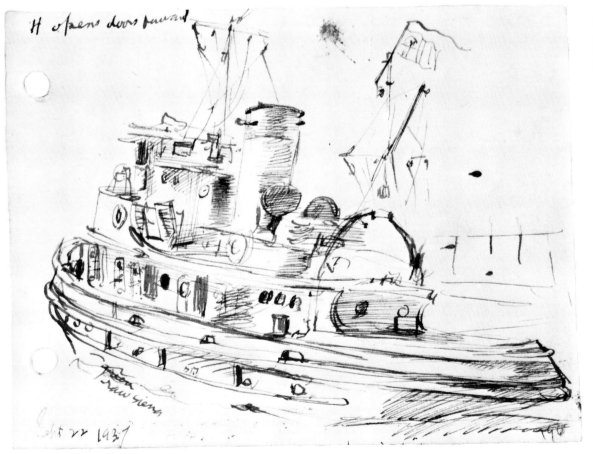

Sketches foreshadowing more finished work included notations as to color and detail

111

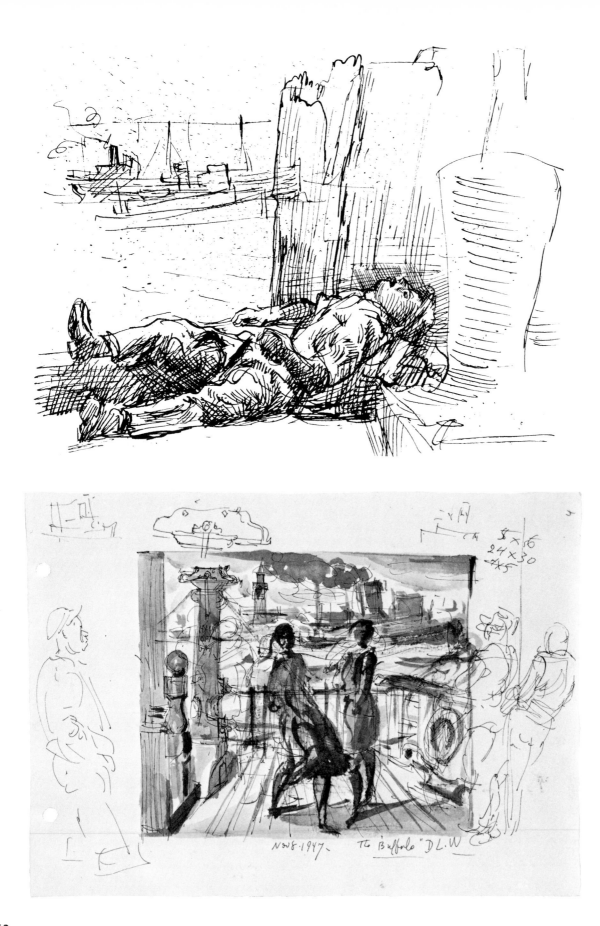

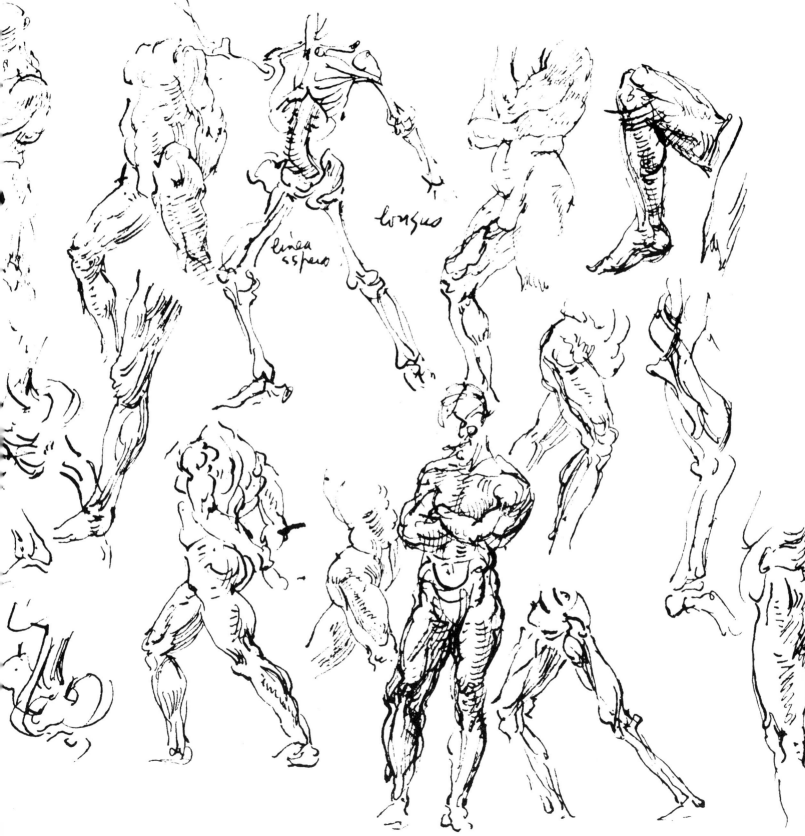

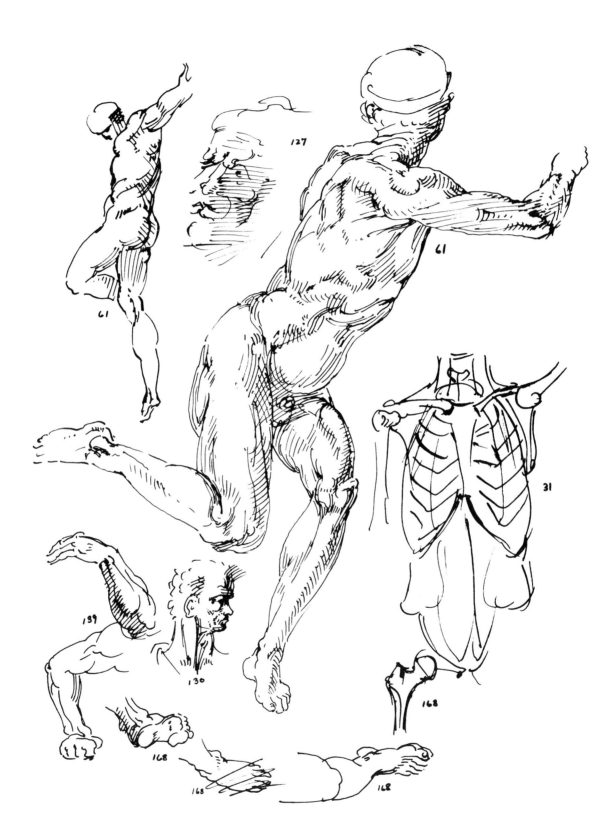

127

61

61

31

139

130

168

168

168

168

Marsh drew the human figure constantly, posing nude models in his studio and filling large papers with studies of the body in action. These studies, like the drawings in his sketchbooks, were primary sources for his large wash drawings and his tempera paintings. Both sources, in Isabel Bishop's phrase, "nourished his concept." These figures drawn from life swarm onto his Coney Island beach and across his burlesque stage. In the early 1940's he began an intensive study of the anatomy of the human body and mastered it so well that he could draw the figure with accuracy in any position without reference to a model.

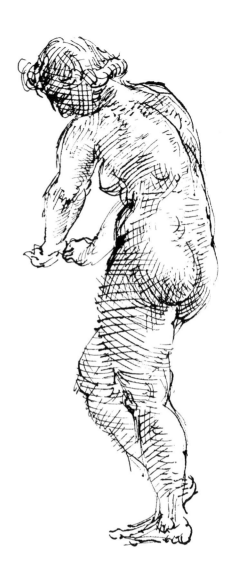

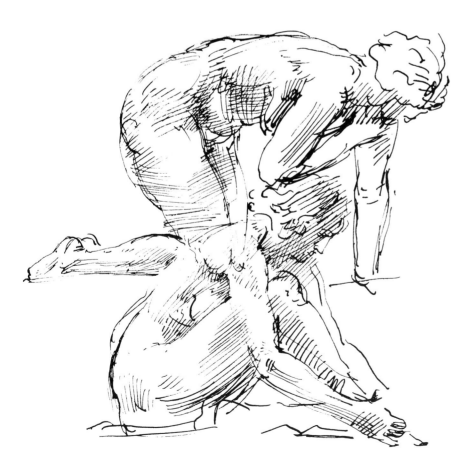

The opposite page was destined for Marsh's book *Anatomy for Artists,* published by American Artists Group, 1945.

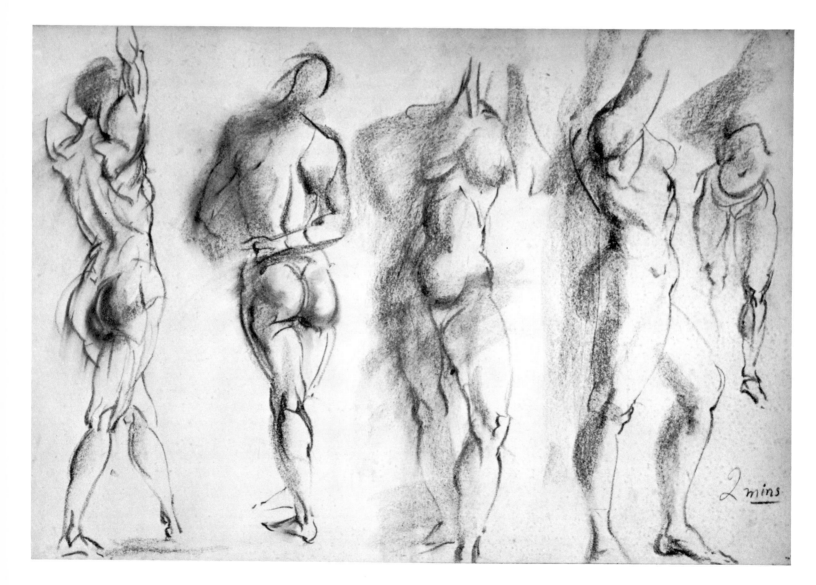

Sketches from life.
Collection of Mr. and Mrs. Lloyd Goodrich. 1944.

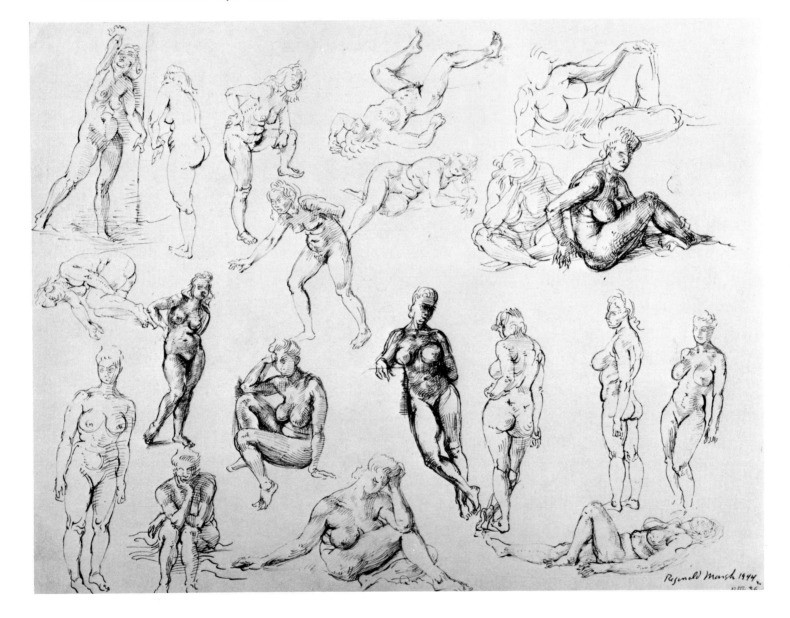

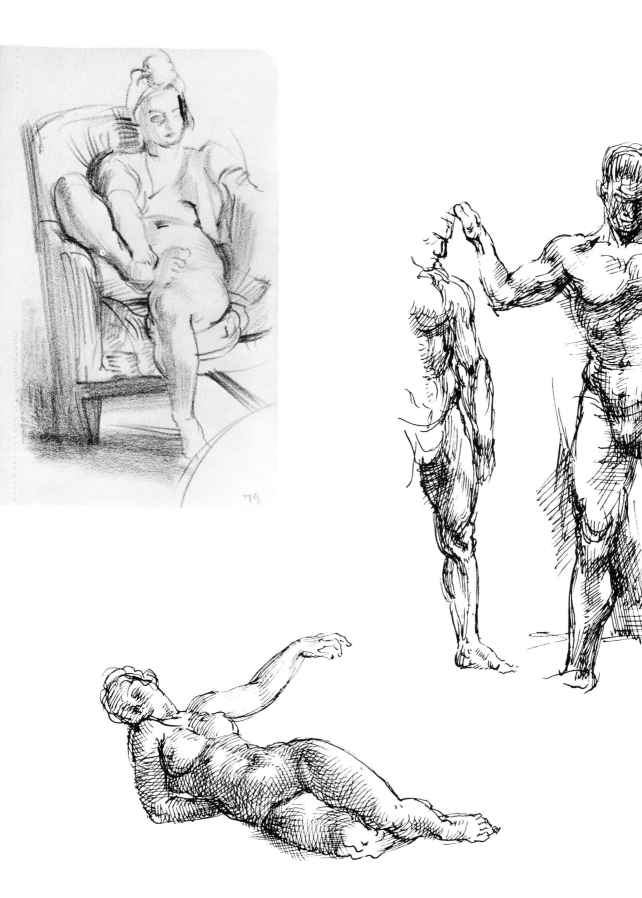

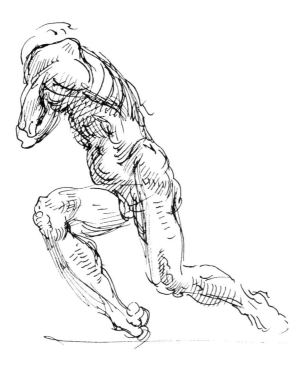

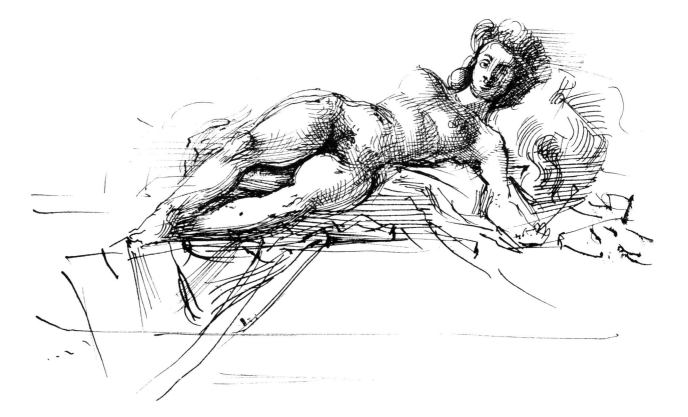

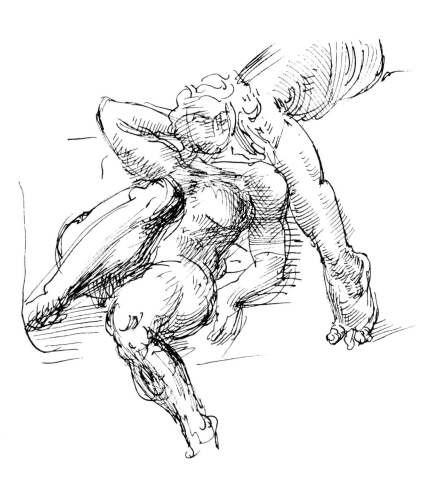

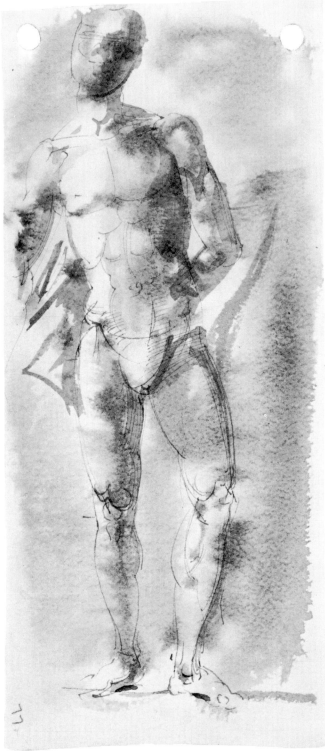

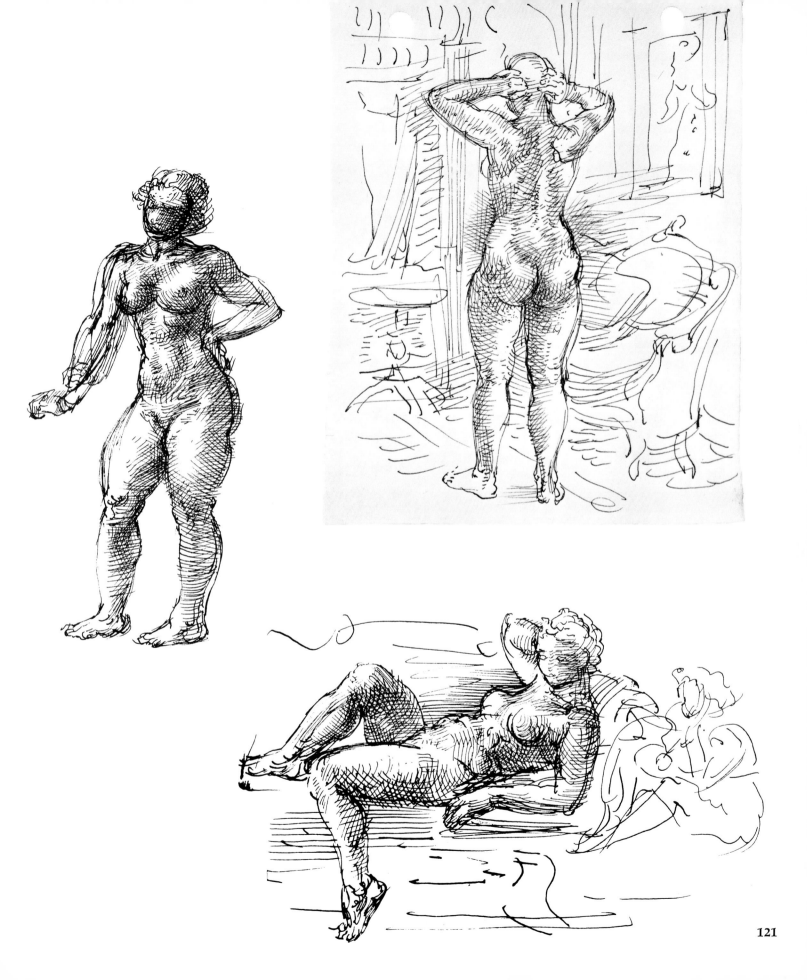

Operation In 1946 Marsh underwent an operation for an umbilical hernia at New York Hospital. With his insatiable curiosity, he sketched while the doctors operated! When I came upon these clinical drawings, I recalled a time during the Second World War when I was recuperating from a wound I received during the Italian campaign. A doctor at the base hospital, learning that I was an artist, told me that if he could get me on my feet in time he wanted me to sketch an operation

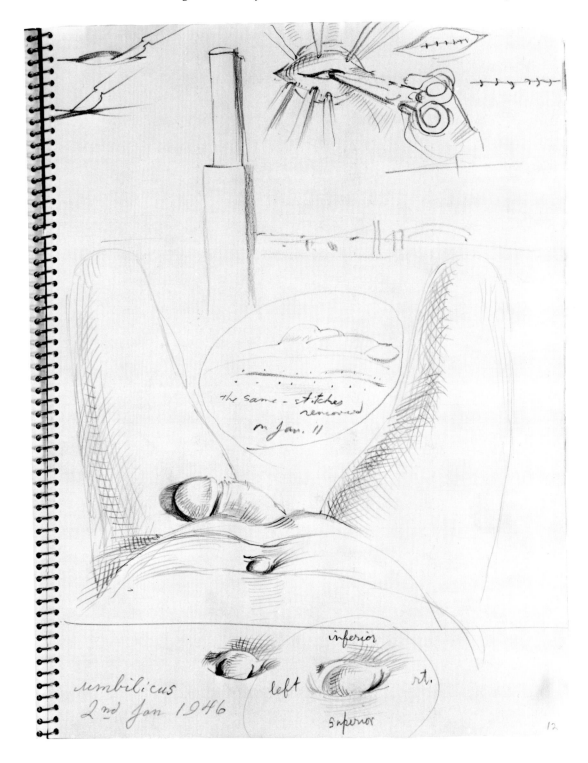

the same - stitches
removed
on Jan. 11

umbilicus
2nd Jan 1946

inferior
left rt.
superior

he was to perform on a soldier's thigh—"a beautiful double aneurysm." He wanted a record of the event.

When the time came, they stood me on a box above the operating table and I drew as best I could the bloody mass of the soldier's leg. I woke up in my own bed; they told me I had fainted. I apologized to the doctor for my failure. "Oh, no," he said, "before you passed out you did a great job!" Reginald Marsh was made of sterner stuff.

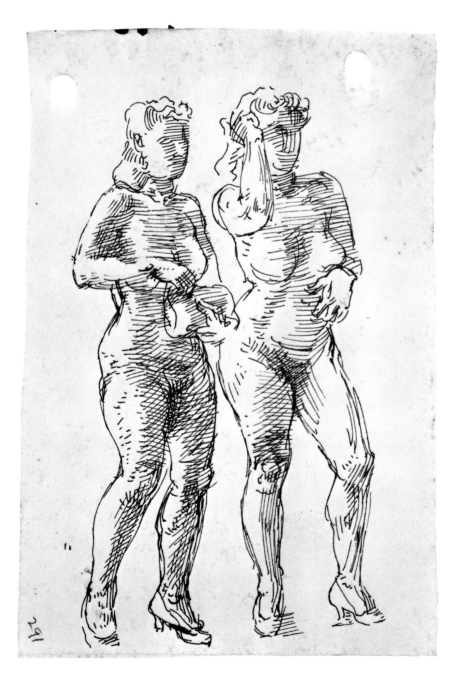

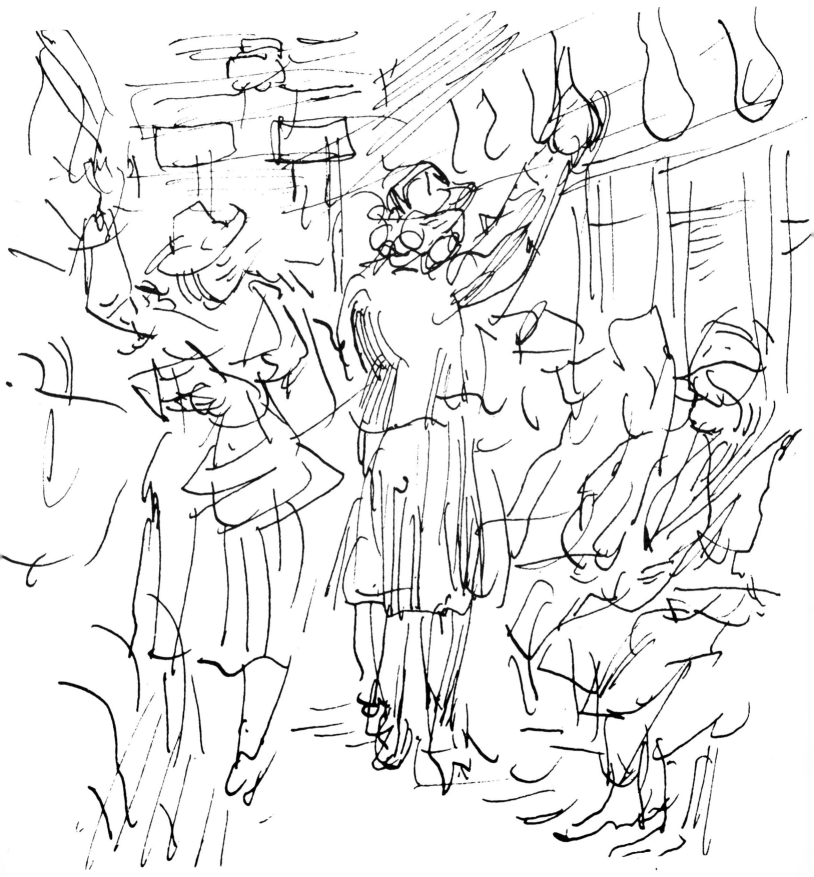

Wherever the crowd was, Marsh loved to be. Not for him the quiet country-side or the solitary portrait. He loved the sidewalks of New York and the Coney Island Midway for their teeming bustle. In the subway or the elevated railway he found this crowd held captive for him to draw. Parties, bars, and nightclubs were wonderful vantage points for his observation, and most of his portrait sketches are of people singled out in the confusion. Was the New York of the Twenties gayer and friendlier than the present time, the thirties kindlier—or was it only Marsh's great compassion which now makes it seem so? He was completely unsentimental, and yet he somehow made his New York, his world, the Great Good Place.

A rainy day on Forty-second Street.

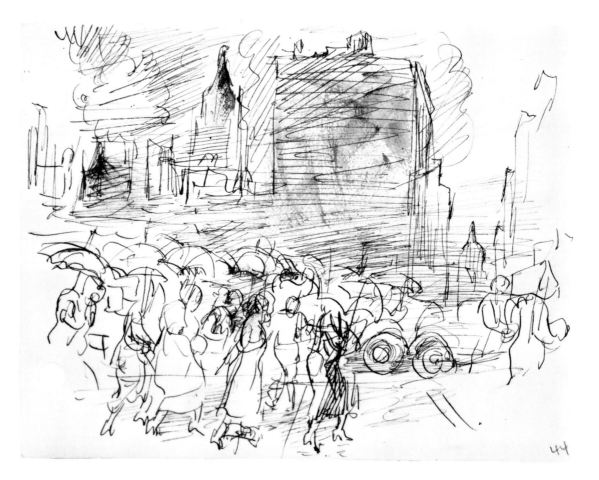

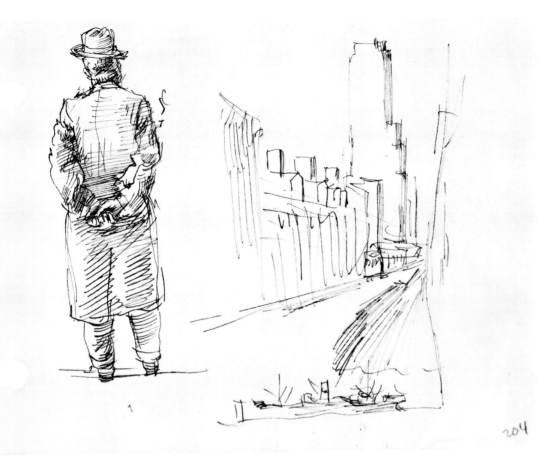

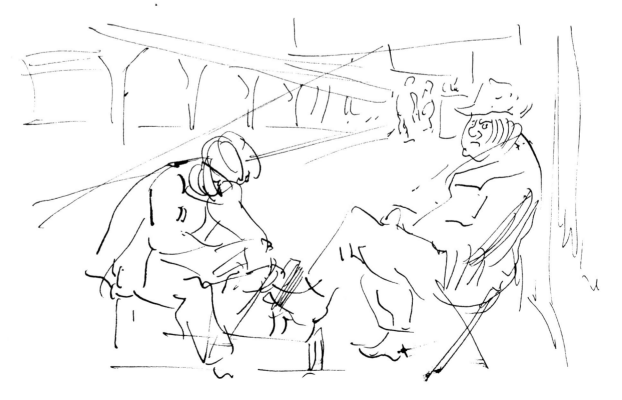

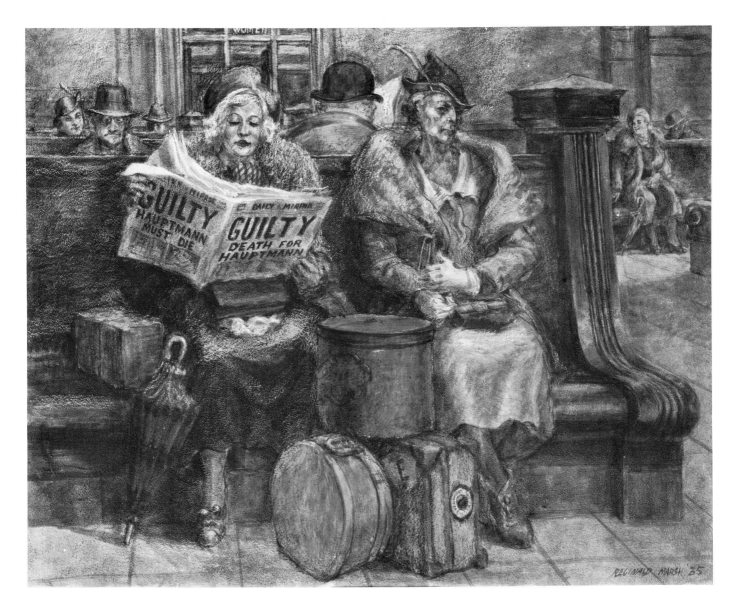

Hauptmann Must Die.
Tempera. Collection of Mrs. Reginald Marsh. 1935.

Penn Sta.

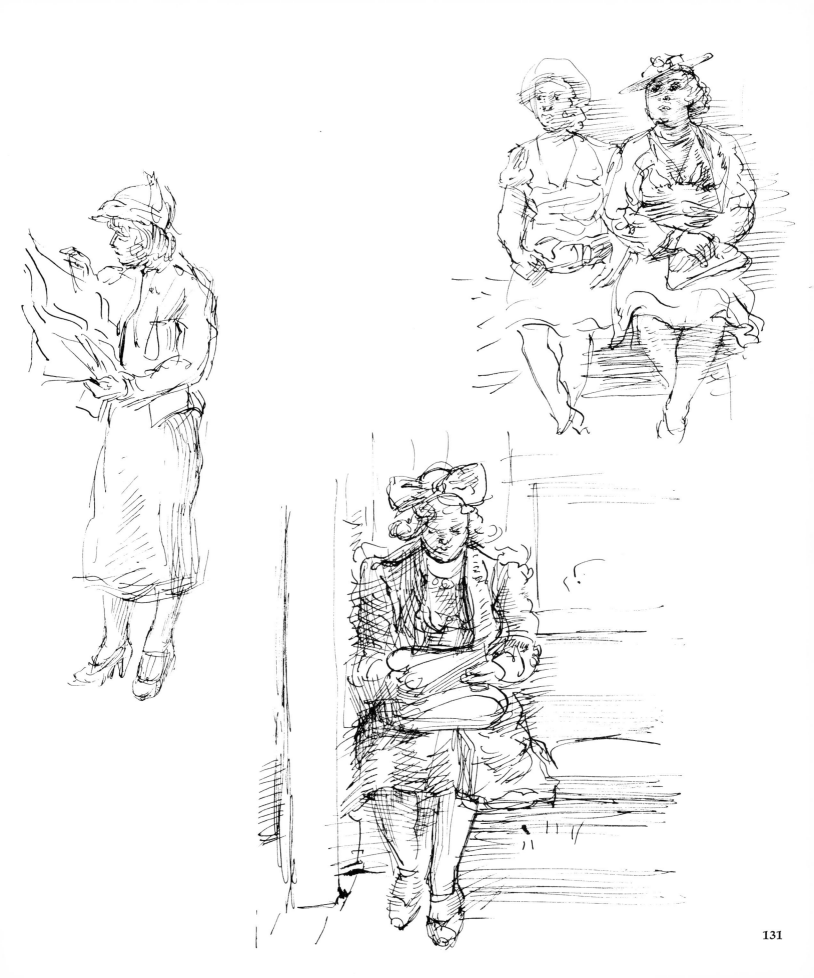

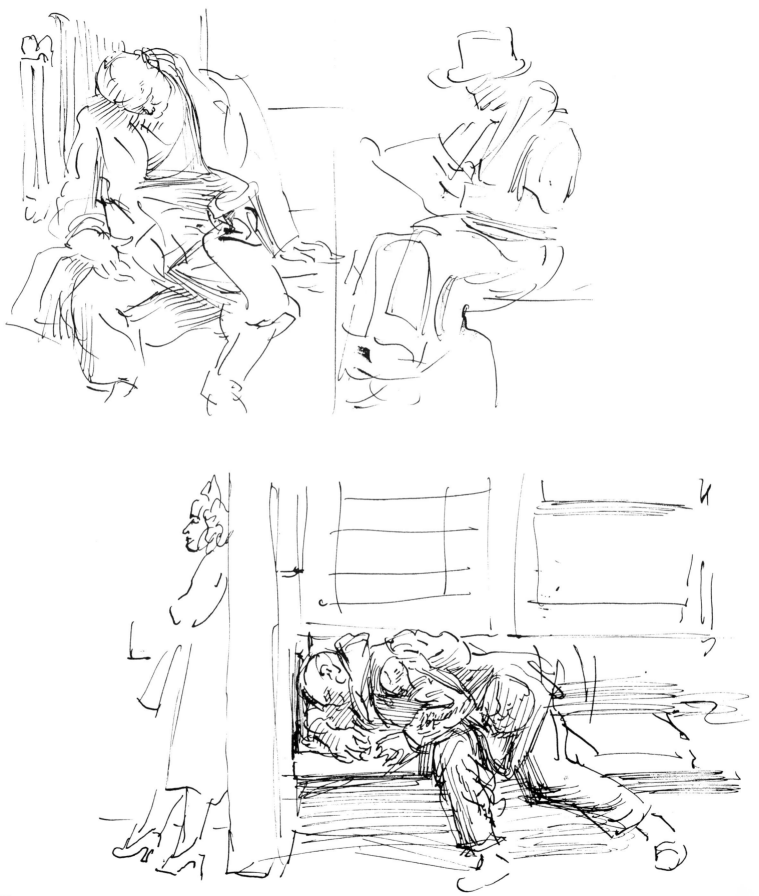

Why Not Use the "L"?
Tempera. Whitney Museum of American Art, New York. 1930.

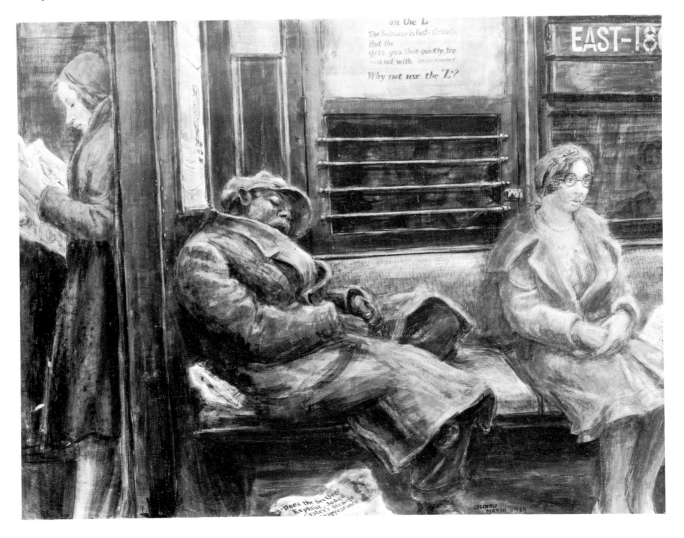

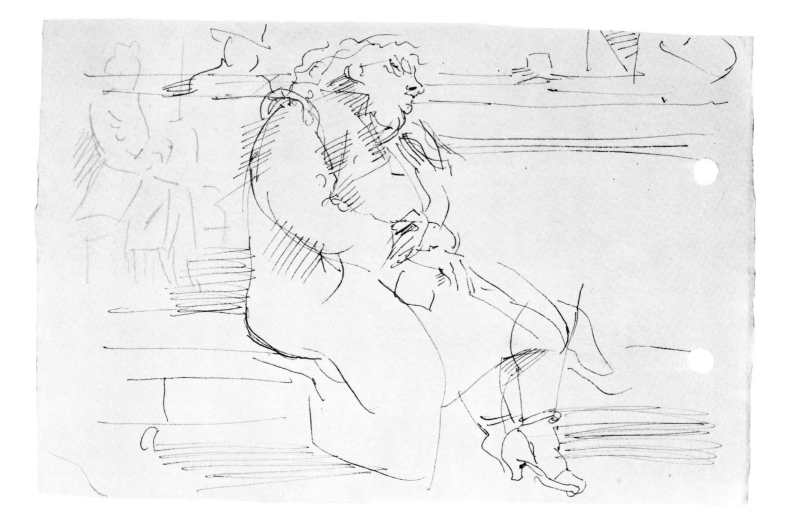

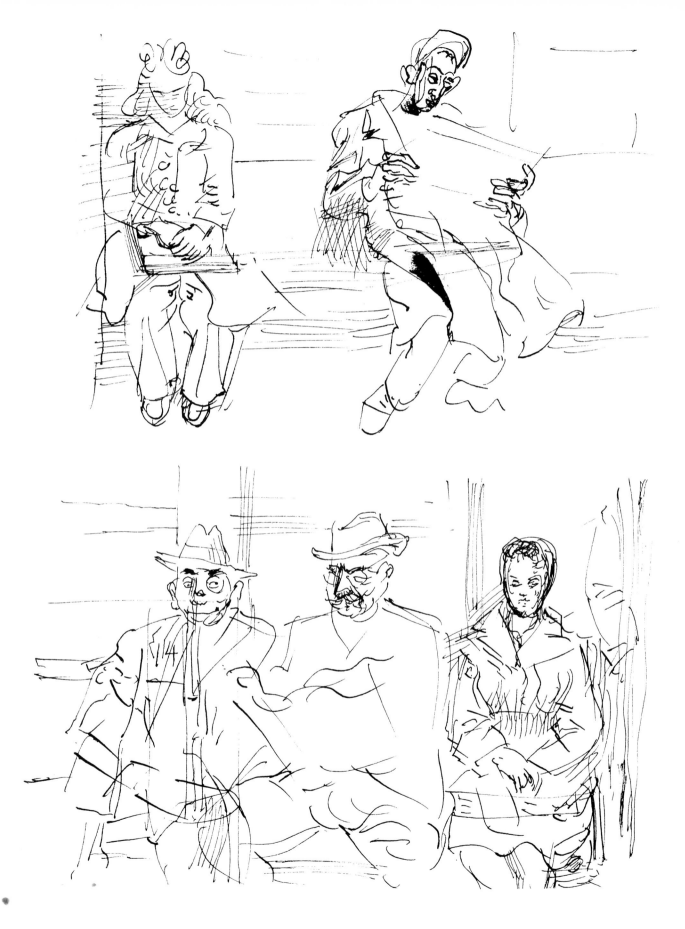

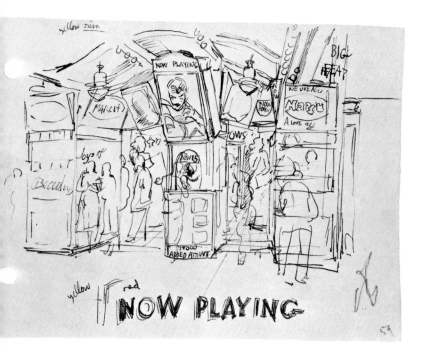

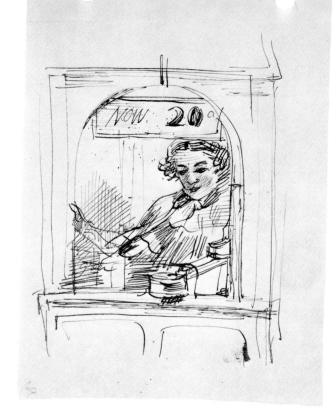

East 14th Street

Twenty Cent Movie.
Tempera. Whitney Museum of American Art, New York. 1936.

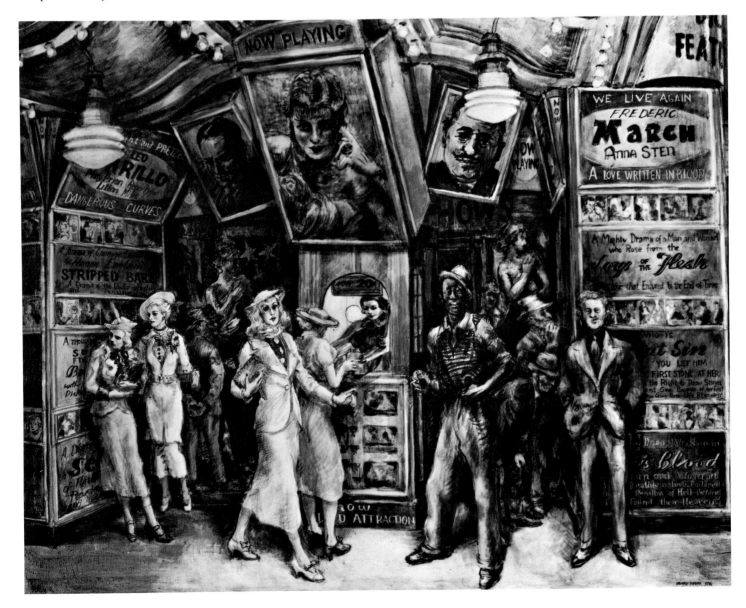

At the Bar

Top of
Mark
Hopkins

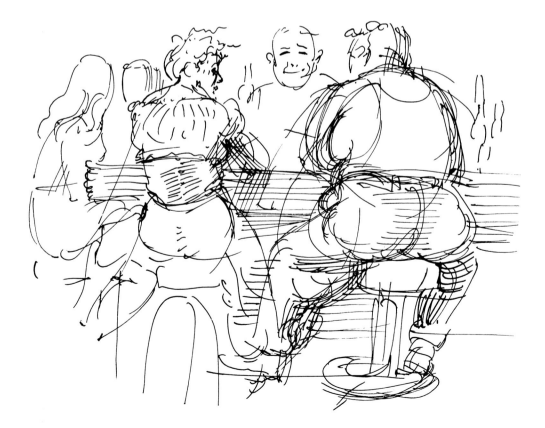

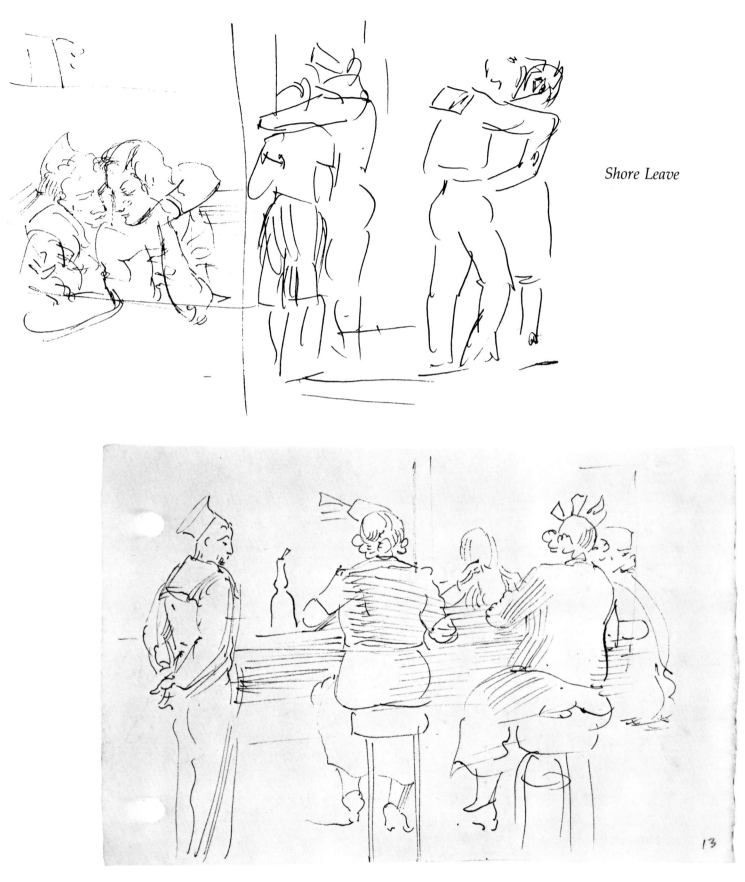

Shore Leave

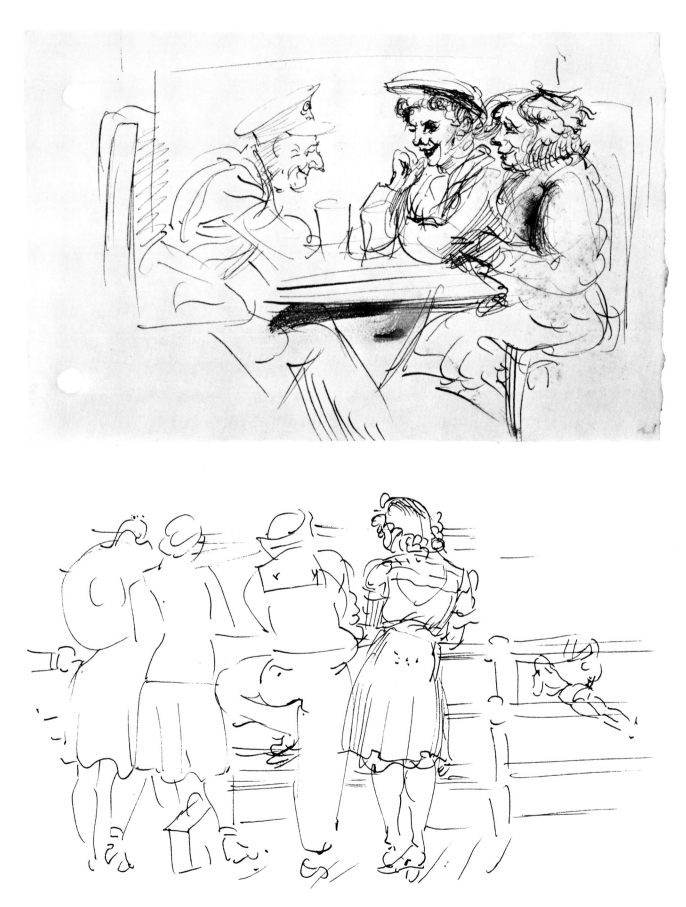

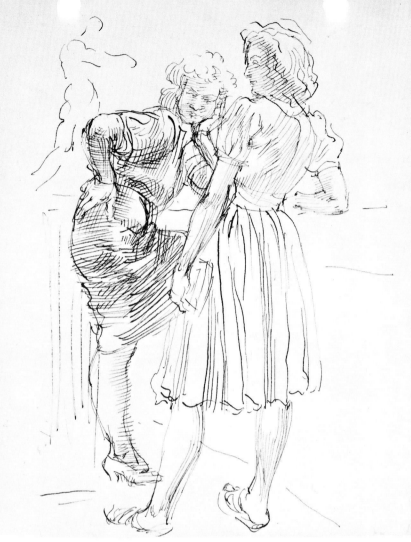

Sailors and Girls, Central Park

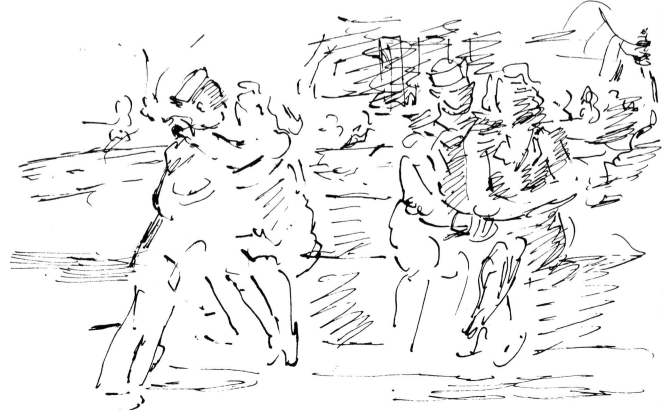

Jury Duty

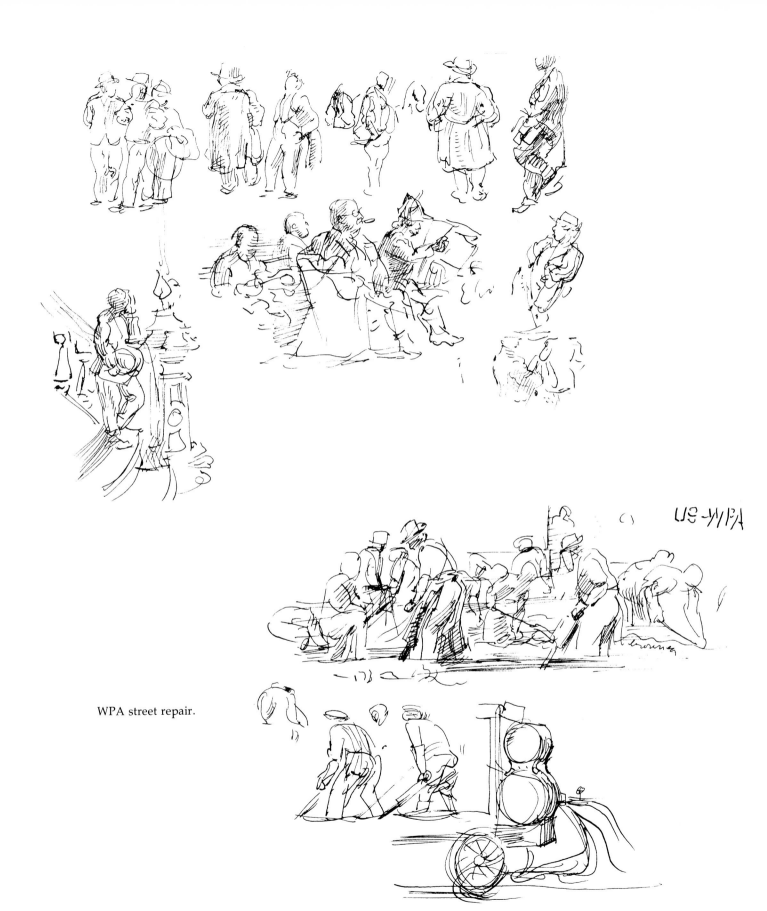

WPA street repair.

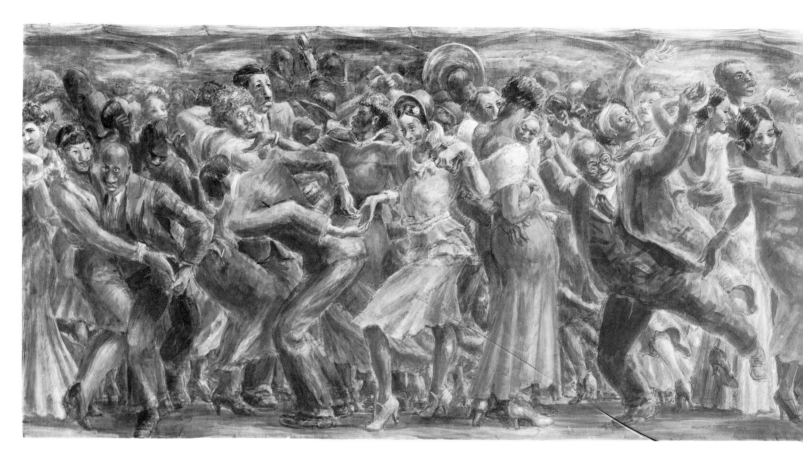

Savoy Ballroom.
Tempera. Detroit Institute of Arts. 1931.
Gift of Mrs. Lillian H. Haass.

Stomping at the Savoy

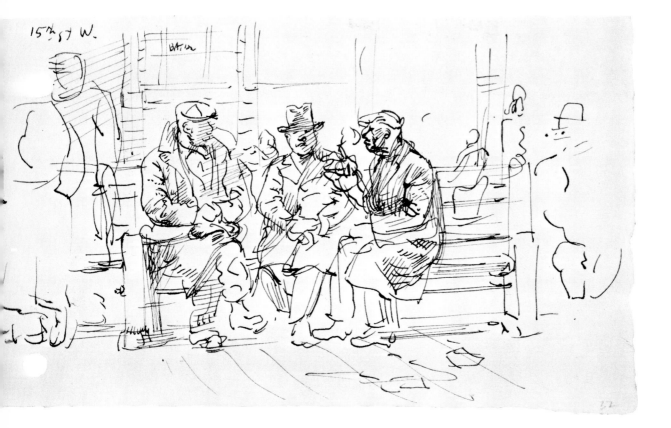

15ᵗʰ st W.

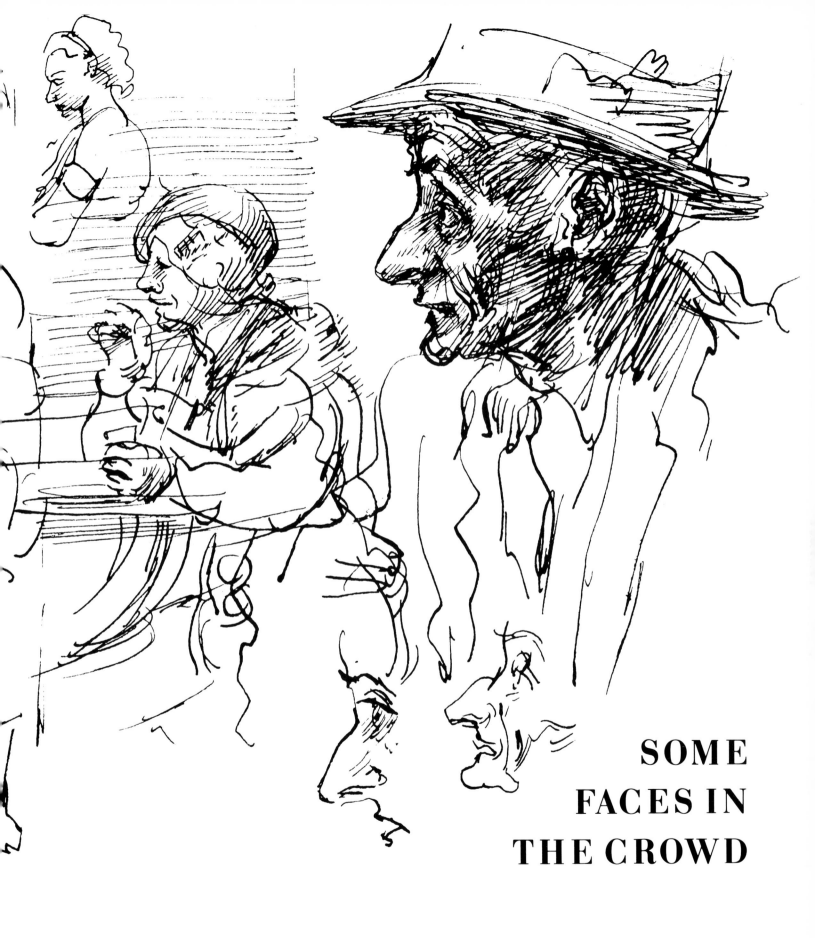

SOME
FACES IN
THE CROWD

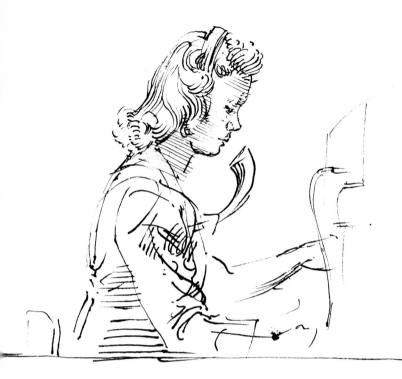

Walter Kerr has observed of Marsh's early theater sketches, drawn for newspaper publication, that they excel for qualities of posture, gesture, and action rather than for portraiture. In his sketchbooks there is a remarkable progression in his drawing of faces—from a rather timid sensitivity, as in the head of Alyse Gregory, to the bold, sure delineation of Philip Evergood, John Marin, and Guy Pène du Bois.

Mr. Broe, page 149, was a roustabout who often posed for Marsh as hobo or man-in-the-street. He was a favorite of New York artists in the Thirties, esteemed for the well-tempered humanity which was expressed in his philosophy as well as in the configurations of his face and body. I believe it was Raphael Soyer who introduced him to Marsh.

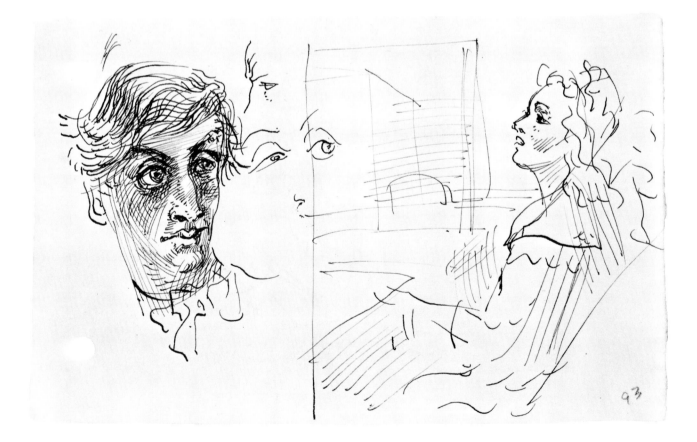

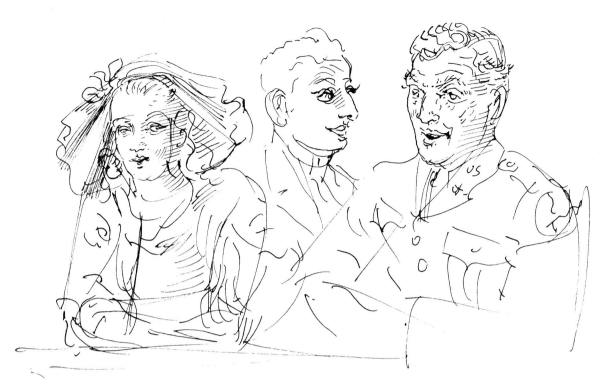

Felicia Marsh and two views of the Marshes' friend Richard Nutt.

In the Marshes' apartment
on Stuyvesant Square
during World War II.

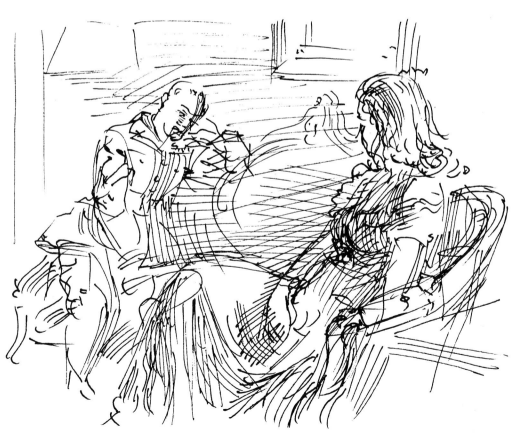

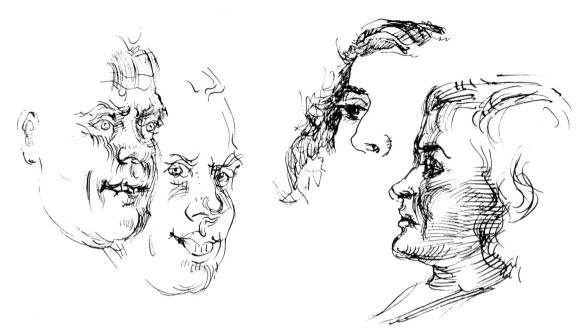

Reginald Marsh's friend Augustus Kelley on left.

The artist's wife and his friend the artist Philip Evergood.

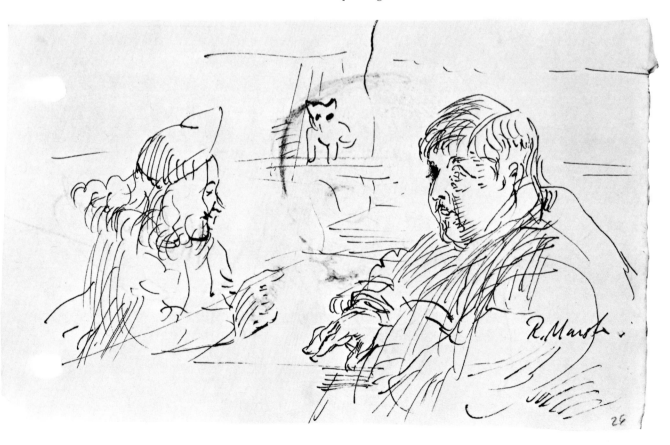

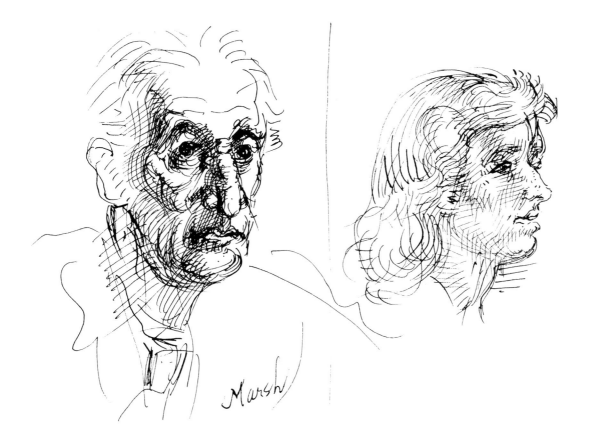

Marsh

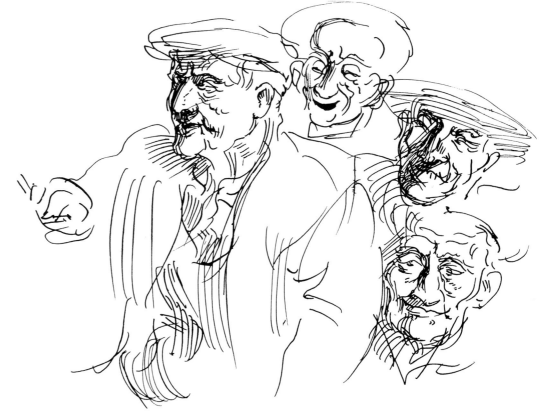

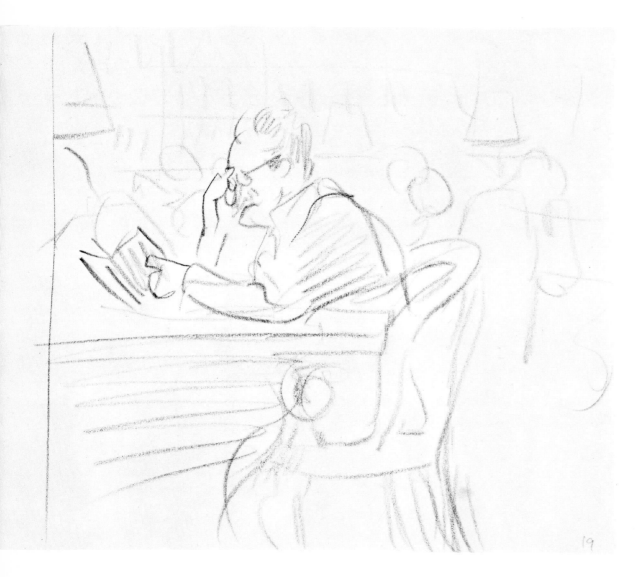

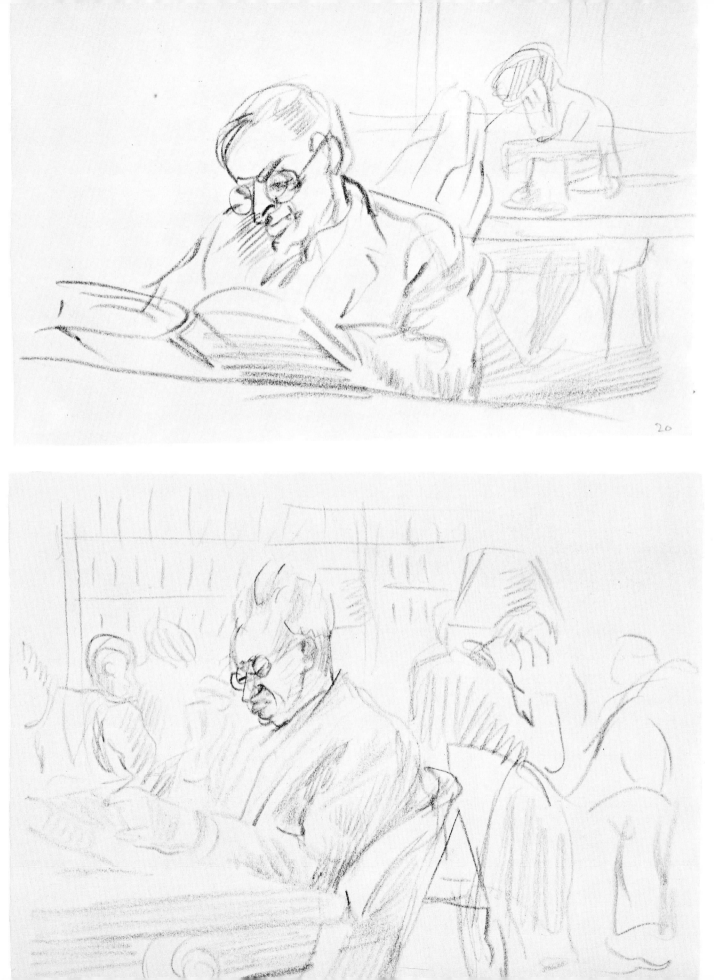

155

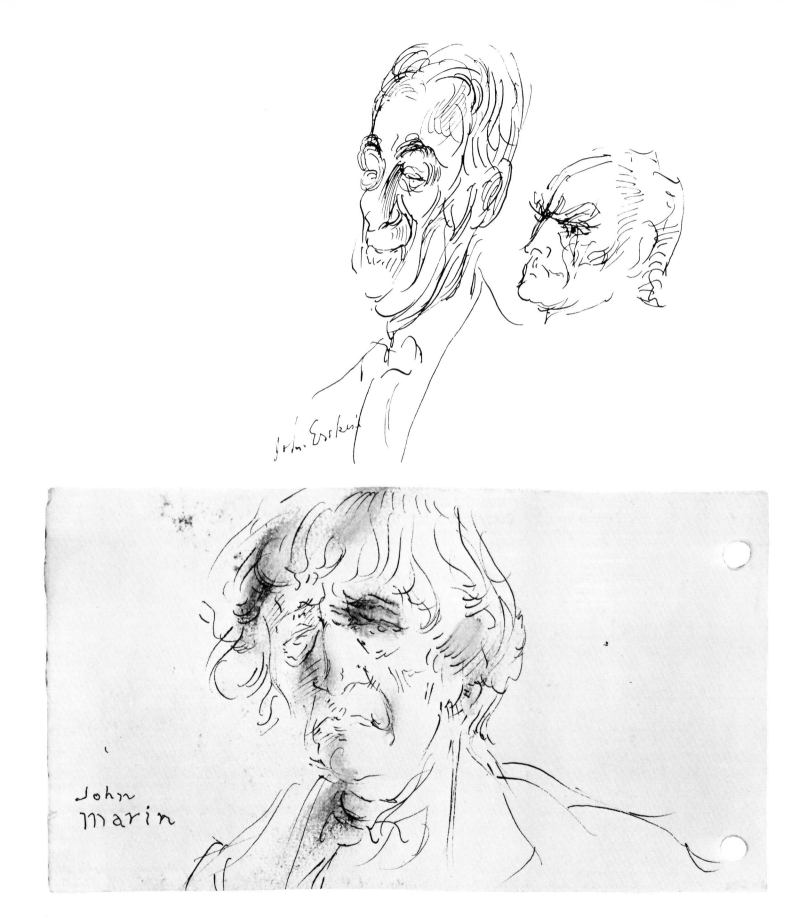

John Erskine

John Marin

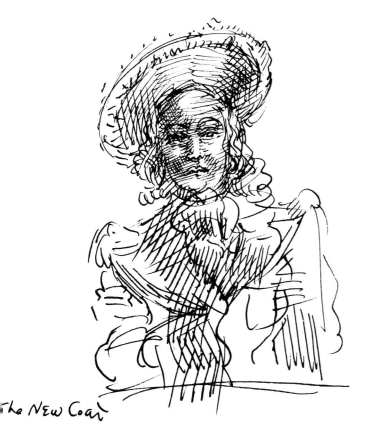

The New Coat

Felicia Marsh.

Edward Laning.

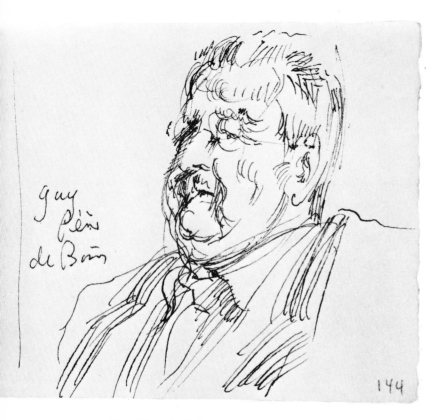

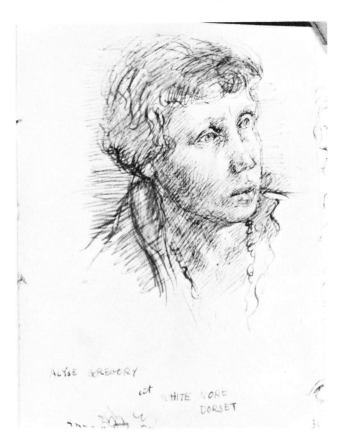

Guy Pène du Bois.

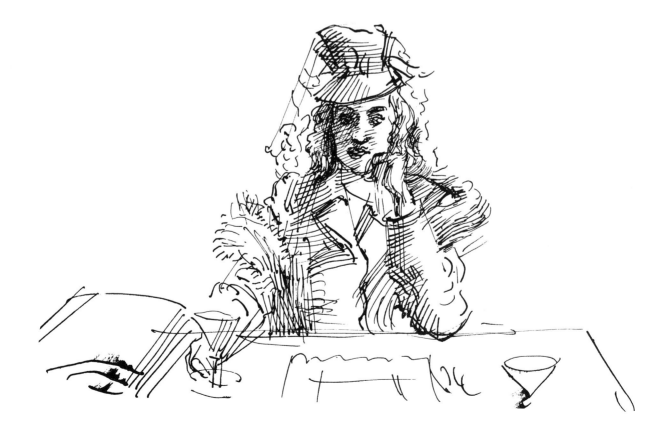

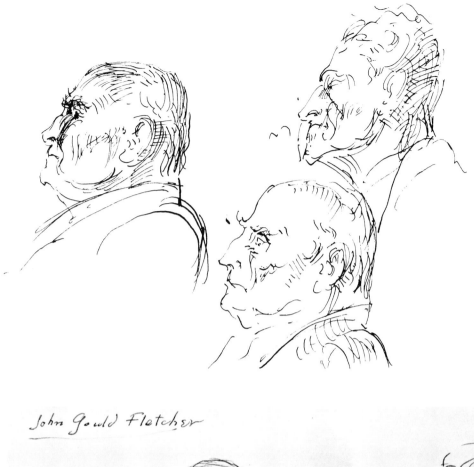

John Gould Fletcher

General Eisenhower at the Metropolitan Museum of Art, with director Francis Henry Taylor at right.

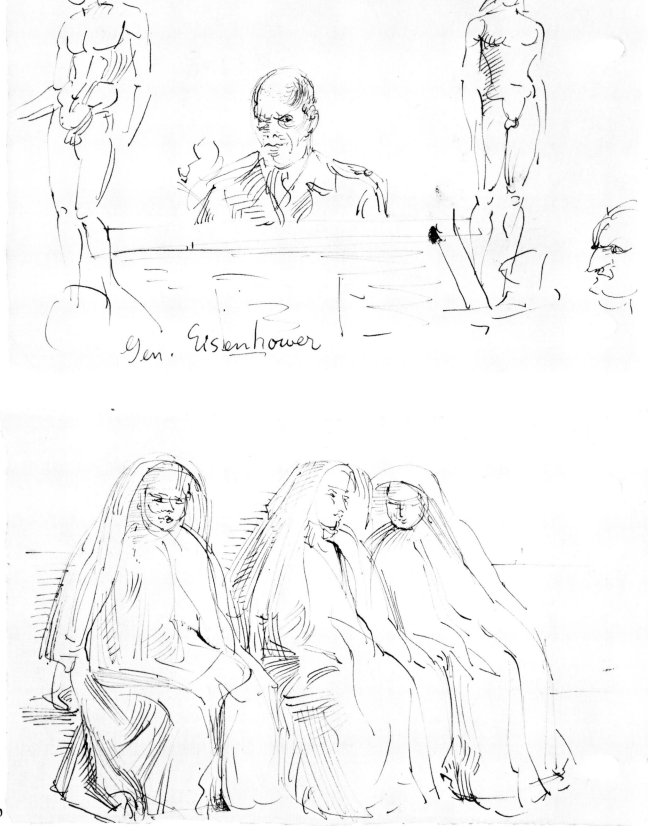

Gen. Eisenhower

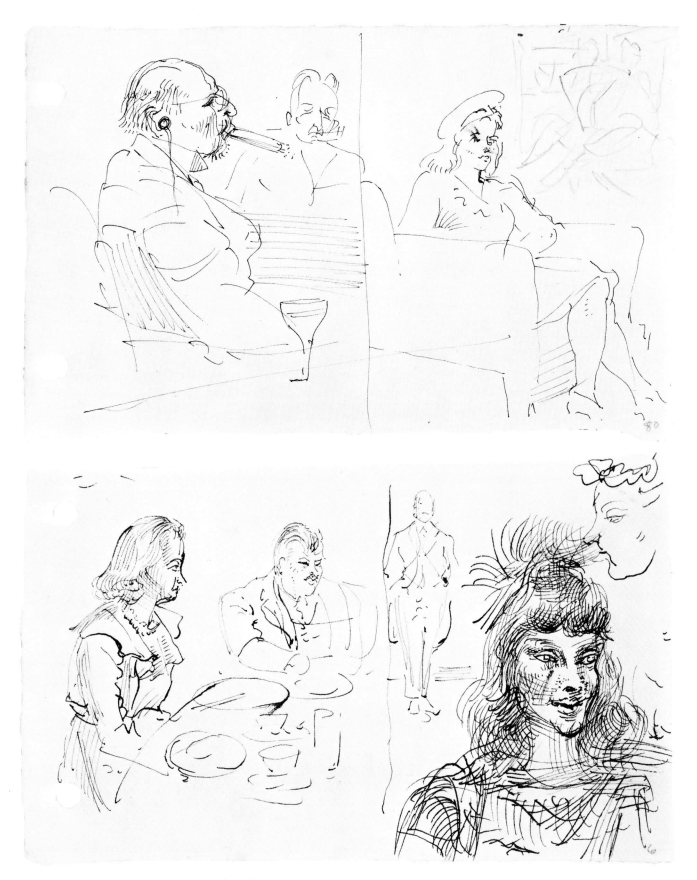

Felicia Marsh with Richard Eames and, at right, "Zippy" Perkins (Mrs. Douglas Gorsline), daughter of Scribner's editor Maxwell E. Perkins.

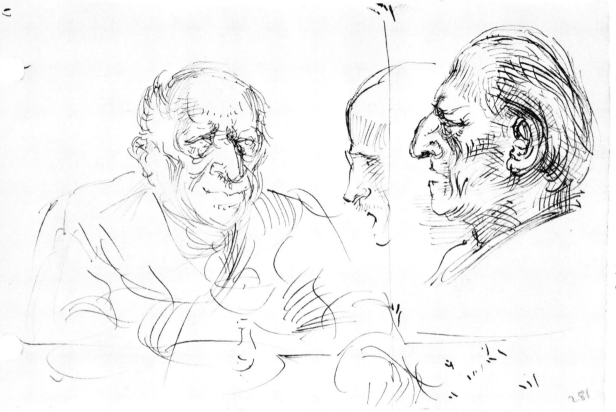

Front and side views
of the artist Leon Kroll.

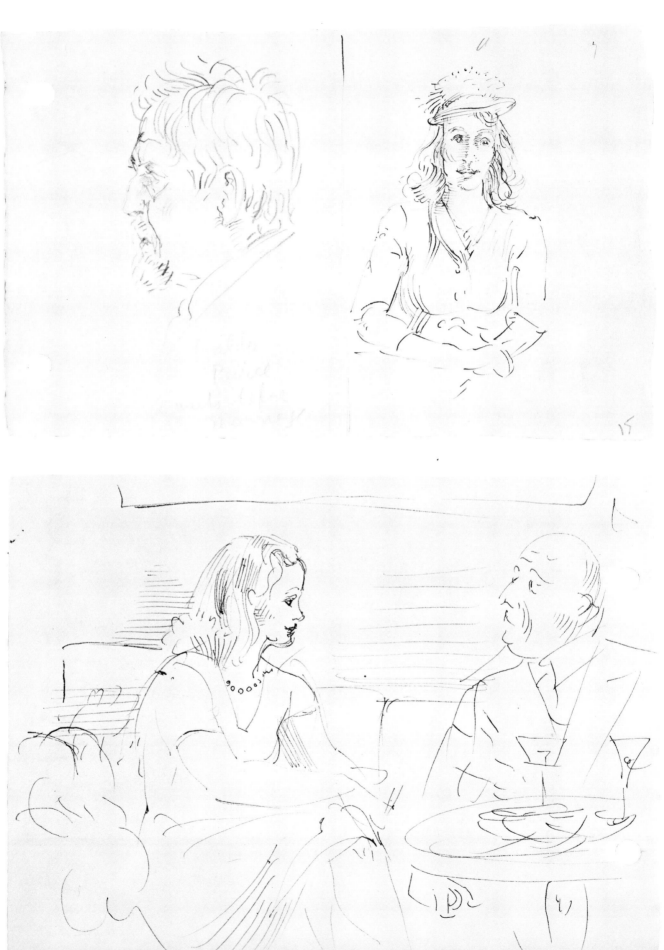

TOTEM POLE

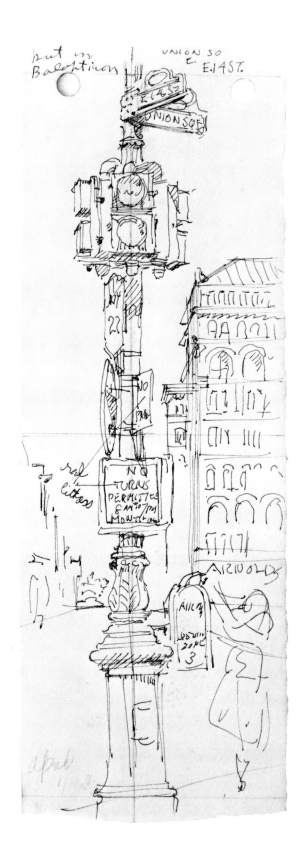

"Bishop's-crook" lampposts lighted the streets of New York for many decades. Introduced in the 1890's, its elegant form, reminiscent of an ancient Roman candelabrum, corresponded gracefully with the arcades of the cast-iron architecture of the time.

By 1954, when Marsh made this sketch, it was already the spar of a sunken ship, covered over with the barnacles of traffic lights, highway numbers, and mailboxes. Nevertheless, he could still trace its raddled beauty. It has been torn down now and replaced by a nondescript floodlight.

The building in the background, designed in the Romanesque style of H. H. Richardson, still stands. Marsh's studio was on the top floor—the fourth and fifth windows from the left.

Thou, like the parti-colored world itself—like infinite,
teeming, mocking life!
Thou visor'd, vast, unspeakable show and lesson!

—WALT WHITMAN, *Leaves of Grass*,
First Annex: "Sands at Seventy"

Taxi.
Estate of William Benton. 1953.

Chronology

1898	Born in Paris, March 14.
1900	Family settled in Nutley, New Jersey.
1914	Family moved to New Rochelle, New York
1915–16	Attended Lawrenceville School.
1916	Entered Yale.
1916–20	Made illustrations for *The Yale Record*.
1920	Graduated from Yale and moved to New York, where he worked as a freelance illustrator.
1922–25	On the staff of the New York *Daily News,* drawing a daily column of theatrical sketches.
1922–29	Designed and executed theater curtains for "The Greenwich Village Follies."
1923	Collaborated with Robert Edmond Jones on curtains and sets for The Provincetown Players. Joined the Whitney Studio Club.
1923	Married the sculptor Betty Burroughs.
1924	First one-man show, at the Whitney Studio Club.
1925	On the staff of *The New Yorker*.
1925–26	Went to Paris for six months. Visits to London. Copied works by Rubens, Titian, Rembrandt, and Delacroix.

1927–28 Studied with Kenneth Hayes Miller at the Art Students League.

1928 Took his first studio on Fourteenth Street.

1931 From this year he had one-man shows at the Frank K. M. Rehn Gallery at frequent intervals until his death. Also from this year his work was included in most of the national exhibitions of American art.

1934 Married the painter Felicia Meyer.

1935 Commissioned to paint two murals in the Post Office Building, Washington, D.C.

1935 From this year he taught drawing and painting during many summers at the Art Students League.

1937 Commissioned by the Treasury Department to paint a series of murals in the rotunda of the United States Custom House, New York

1937 Elected an Associate of the National Academy of Design. In 1943 he was elected Academician.

1942 In this year he began to teach throughout the year at the League and continued to do so for the rest of his life.

1945 His book, *Anatomy for Artists,* published.

1954 Awarded Gold Medal for Graphic Arts of the National Institute of Arts and Letters.

1954 Died of a heart attack in Dorset, Vermont, July 3.

Photograph Credits

Geoffrey Clements: 31, 47, 53, 67, 70, 76, 80, 107, 116, 117, 137, 165
Fritz Henle—Black Star: 12, 15
Peter A. Juley & Son: 55, 61, 79, 114, 129, 133
E. B. Luce Studios, Worcester, Mass.: 52
Gene Pyle: 8, 16, 17, 20, 29
Nathan Rabin: Frontispiece, 51
Von Behr: 11